IMAGES
of America

SUGARITE
COAL CAMP

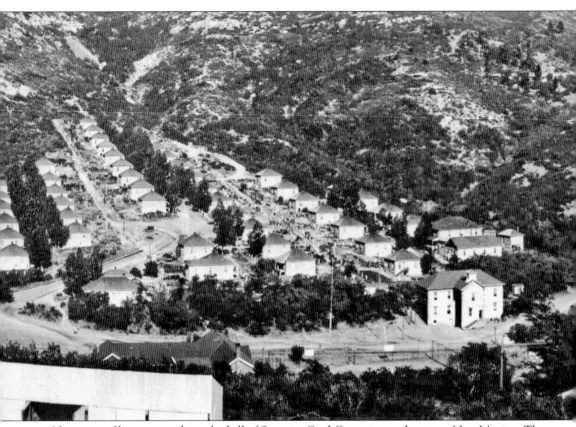

Neat rows of houses march up the hill of Sugarite Coal Camp in northeastern New Mexico. The two-story building at lower right is the school for the miners' children. At lower left is part of a garage. The long roof of the clubhouse can be seen just above the garage. (Courtesy of New Mexico State Parks.)

ON THE COVER: Men and mules partnered at Sugarite Coal Camp to wrest coal out of the mines. Here, miners and a man believed to be stable boss John Ross display their two-legged and four-legged power in a portrait near the camp's mule barn. The building still stands in Sugarite Canyon State Park and is used in park operations. (Courtesy of New Mexico State Parks.)

IMAGES
of America

SUGARITE
COAL CAMP

Patricia Veltri and Patricia H. Walsh
Foreword by Mickey Baker

ARCADIA
PUBLISHING

Published by Arcadia Publishing
Charleston, South Carolina

Printed in the United States of America

Library of Congress Control Number: 2017956034

For all general information, please contact Arcadia Publishing:
Telephone 843-853-2070
Fax 843-853-0044
E-mail sales@arcadiapublishing.com
For customer service and orders:
Toll-Free 1-888-313-2665

Visit us on the Internet at www.arcadiapublishing.com

*This book is dedicated to the miners of
Sugarite Coal Camp and their families.*

CONTENTS

FOREWORD

I am often asked what it was like being a "camp kid." My response is always "Great!" We didn't have much money, which I think in some ways was a good thing. My two brothers and I were forced to use our imaginations in games we played and our ingenuity in making our toys. We made kites of sunflower stems, newspaper, and rags. Our fishing poles were sticks, string, and hooks. We were so proud of ourselves—the kites flew and the poles gave us fish. What really mattered was we felt a sense of accomplishment and independence.

We did not have many of the advantages of the Raton children, but we kept busy with marble tournaments, hiking, baseball, tennis, basketball, swimming (in the creek) and sledding during the long winters.

Our elementary school in Sugarite was excellent. We learned the basics, along with good citizenship, discipline, and the knowledge that education was a privilege that deserved our best effort. Also, the girls went to sewing, the boys went to manual training, and we all went to music.

The people who lived in Sugarite were one big happy family. They cared about each other. If someone was in need, everyone gathered to help. I consider myself lucky to have been born in Sugarite Coal Camp. I grew up being taught about the things that really matter. I learned about giving of yourself for others and sharing, no matter how little you had. I saw the deep love and respect the many immigrants with whom we shared our lives had for this country. They were truly amazing people. The memory of their hard work, many sacrifices, and love will remain with me forever.

As children we were happy knowing our parents were always there for us. After school, walking up to our small house and smelling mom's homemade bread or peanut butter cookies—what a treat! Being able to fish just a stone's throw from our front door—what child wouldn't love that?

Does having everything you want make you happy? I guess so, because I was really a happy kid!

—Mickey Baker

ACKNOWLEDGMENTS

"King Coal" played a significant role in our country's development. The coal mining industry also attracted immigrants from many nations to remote places like Sugarite Coal Camp.

Here we hope to bring that era to life through the stories and images of former Sugarite Coal Camp residents and their relatives. Many assisted us by contributing time, expertise, or the use of cherished family photographs and memorabilia. Space restrictions forced us to make hard choices from many wonderful images. We also did our best to spell names correctly, but at times we had to rely on old captions with questionable spellings.

We especially thank former Sugarite residents Mickey Baker and Mary King for patiently answering questions about their daily life in the camp. We also are indebted to Antoinette Bertola, Alberta Blouin, Bob and Jan Dye, Mozelle Falletti, Felipe Fresquez, Paula Grantham, Charles Hayes, Pam Hunnicutt, Dorothy Kay, Mary Alice Manfredi, Katy Marchiondo, Richard Newton, David Stafford, Jack Walton, Robert G. Walton, and George Yaksich.

Most of our images come from the archives of New Mexico State Parks. Special thanks to Robert Stokes, New Mexico State Parks archaeologist, for all his help. Images are courtesy of New Mexico State Parks unless otherwise noted.

Thanks also to the Raton Museum and Pueblo County Historical Society for additional photographs. Thayla Wright and Dennie Gum of the Arthur Johnson Memorial Library in Raton kindly helped us locate images and documents and assisted with scanning chores.

We owe a huge debt to Dan and Lorene Schamber. As volunteers for Sugarite Canyon State Park, Dan and Lorene dedicated many years and much effort gathering oral histories of former Sugarite residents. They shared what they learned, especially on countless coal camp tours. The Schambers have referred to this work as a "labor of love."

We also thank the Friends of Sugarite for their support.

As a high school teacher in the 1980s, Mary Nell Mileta organized Raton students to gather memories of coal camp residents through photographs and letters. Many of those artifacts remain on display at Sugarite Canyon State Park, providing additional information for this book.

We thank Arcadia Publishing and our editors, Caitrin Cunningham and Henry Clougherty.

Finally, we are grateful to Jim and Al for their love, patience, and support.

INTRODUCTION

There is a good reason many people have never heard of the historic Sugarite (Sugar-EET) Coal Camp, in a remote canyon of northeastern New Mexico near the Colorado border.

Unlike nearby camps, Sugarite lacked the drama of deadly explosions or violent strikes. But this short-lived company town gave poor immigrant families a firm foothold in the United States and created cherished memories for their children.

Sugarite Coal Camp had its origins in the Cretaceous Period some 60 million years earlier, when *T. rex* stomped through coastal swamps near the vast inland sea dividing North America. Palms and other tropical plants grew, died, and toppled into the muck. With time and pressure, that vegetation morphed into peat, then into coal.

But that coal lay untouched for millions of years. The inland sea dried up. Wet tropics transformed into a dry and rocky place of pinyon pines, junipers, and ponderosa pines. Eventually, generations of native peoples such as Jicarilla Apache, Ute, and Comanche visited Sugarite Canyon seeking other rich resources—pure water, game animals, and abundant edible and medicinal plants.

Spanish rulers included the area in the vast Maxwell Land Grant. In the 1800s, Anglo settlers established ranches and farms. No one knows how Sugarite Canyon got its name. Probably "Sugarite" is a mispronunciation of the creek's name, Chicorica—itself possibly a distortion of Spanish or Comanche words.

Entrepreneurs began coal mining around 1900 with a "wagon mine," shoveling home-heating coal into horse-drawn wagons. In 1912, the St. Louis, Rocky Mountain & Pacific Company ramped up operations, building a beautiful school, an expansive clubhouse for social events, and sturdy block houses on canyon slopes.

Hard and dirty mining jobs drew immigrants of at least 19 nationalities from Eastern Europe, Italy, Greece, Scotland, Wales, Ireland, Mexico, Japan, and elsewhere. As many as 1,000 people speaking seven languages lived in Sugarite at its peak.

For decades, Sugarite coal was shipped regionally as fuel for home heating and train locomotives. But new petroleum products signaled the end, and in 1941, the company announced Sugarite's closure.

Despite its short life, Sugarite affected many. Poor families from places where only the rich were educated watched their children win penmanship awards in English. When free of school and chores, children scampered over wooded hillsides or fished Chicorica Creek.

That is not to say that life was perfect. Miners performed back-breaking work to dig out salable coal. They were paid only for the coal they produced, not for "dead work" such as shoring up mine ceilings or drilling holes for dynamite sticks. They made good winter wages when demand for coal was high. But they sank into debt at the company store in summer, when most miners were laid off. And later in life, no doubt many of them contracted black lung disease.

Still, these tough, self-reliant people planted fruit trees and grew gardens. They raised chickens, ducks, and rabbits. They hunted and fished. They imported grapes to make wine, which sometimes replaced water in the lower compartments of miners' lunch buckets. They played old games like bocce ball and new games like baseball.

In the end, after Sugarite was torn down and its building materials salvaged, what endured were memories. One man remembered walking through the camp as a boy, saying "good morning" in multiple languages. Another recalled stomping grapes, his little feet turning purple.

"We were poor, but we were rich," Lina Giampietri Cash said decades later.

These images illustrate life in one coal camp in the American Southwest, where foreign cultures took root in the soil of a new land.

And our country is richer because of it.

One

EARLY DAYS

Sugarite Coal Camp had its roots in geologic history, millions of years in the past.

What is now Sugarite Canyon once sat along the coastline of a sea long vanished. That shallow inland sea divided the entire North American continent, covering part of what became Mexico, the United States, and Canada. The western boundary of that sea lapped the shores of many western states, including New Mexico. During the Cretaceous Period, the north-south shoreline was tropical and swampy, inhabited by dinosaurs including *T. rex*. The tropical vegetation would grow up and old, eventually falling into the mud. Under the pressure of earth and time, that vegetation transformed into peat and eventually into coal. Meanwhile, during a volcanic period, lava flowed along either side of a long ridge. Unprotected by the basalt left by the lava, that ridge slowly eroded until the onetime ridge inverted, becoming a canyon.

Over millions of years, the landscape shifted from wet tropics to dry, rocky ecosystems of pinyon pine and juniper. Eventually, generations of native people would be drawn to Sugarite Canyon for its rich natural resources of pure water, diverse plants, and wild game.

Under Spanish rule, the region became part of the legendary Maxwell Land Grant. Anglo settlers arrived in the 1800s, turning their hand to ranching and farming.

Finally, around 1900, prospectors realized the value of the coal in Sugarite Canyon and started a small-scale mining operation. By 1912, the canyon was under the control of the St. Louis, Rocky Mountain & Pacific Company, and large-scale operations began.

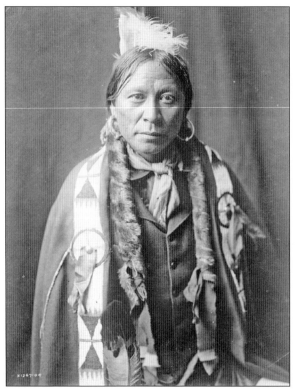

The 30-year lifespan of Sugarite Coal Camp was brief in the human history of Sugarite Canyon. Various native peoples have used the canyon for hundreds if not thousands of years. This includes the Jicarilla Apache, who now have a reservation in western New Mexico. Edward S. Curtis photographed Jicarilla Apache life in the early 1900s, including the man at left and the riders heading to camp below. Others who may have visited the canyon include the Comanche, Ute, and Kiowa. Humans have been drawn to the canyon for its pure water, edible and medicinal plants, and animals to hunt including deer, elk, and turkey. To this day, drinking water from the canyon is piped to the nearby town of Raton, and limited bow hunting is still permitted in Sugarite Canyon State Park. (Both, courtesy of the Library of Congress.)

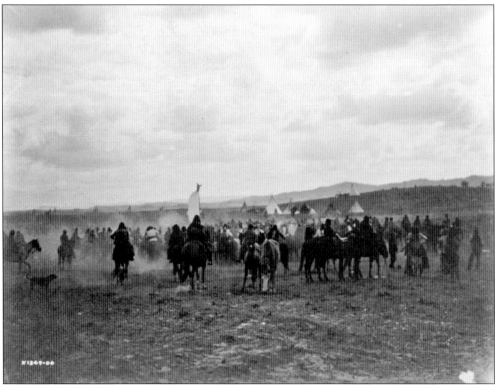

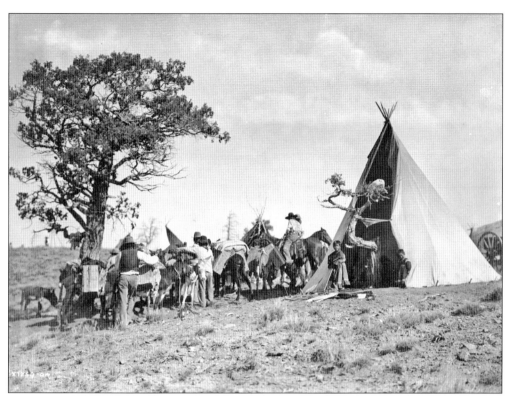

Native people like the Jicarilla Apache used simple, natural construction materials for their early homes in what would become Sugarite Canyon. Above, traders and pack animals gather at a Jicarilla Apache tipi, which appears to have been built around a living tree, possibly a juniper. Two Jicarilla children watch the proceedings from the tipi entrance. The wheel of a wagon can be seen at right, and additional tipi poles are visible in the background. Edward S. Curtis photographed the above scene as well as the image at right of a Jicarilla Apache girl. She wears a traditional choker necklace and the elaborate clothing used for special occasions such as large gatherings of her people. (Both, courtesy of the Library of Congress.)

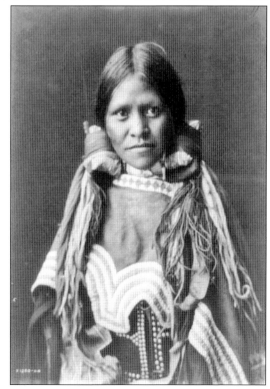

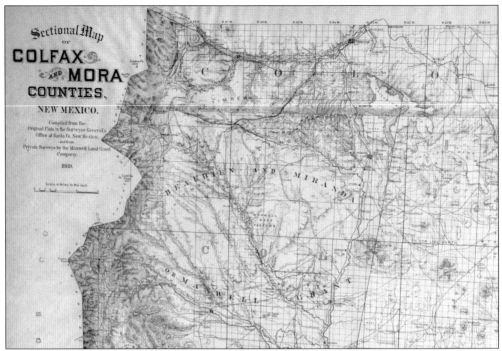

The image above shows part of the Beaubien-Miranda Land Grant, also known as the Maxwell Land Grant. Created in 1841 by the Mexican government on Jicarilla Apache lands, the grant covered 1.7 million acres in what is now northern New Mexico and southern Colorado. The land went to French-Canadian trapper Carlos Beaubien and his partner, Guadalupe Miranda. Beaubien's daughter Luz later married Lucien Bonaparte Maxwell, who eventually took control of the land grant, selling it in 1870. In 1902, part of the original grant including Sugarite Canyon was conveyed to the Raton Coal and Coke Company, later becoming part of the holdings of the St. Louis, Rocky Mountain & Pacific Company. The detail below shows the town of Raton, six miles southwest of what would become Sugarite Canyon. (Both, courtesy of David Stafford.)

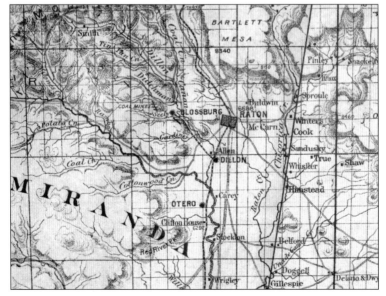

Sugarite Canyon pioneer Ruth Fields Walton is shown in an early and stylish portrait at right. Ruthie, as she was fondly known, became the wife of Robert Earl Walton at the tender age of 15, while her groom, shown below, was a more mature 27 years of age. Together they had three children: Millard, Robert H. "Buster," and daughter Clair. In a 1983 interview, her son Millard recalled that his mother operated a small dairy during the years of Prohibition (1920–1933) and delivered milk and cream to people who ran a boardinghouse in Sugarite Coal Camp. The boardinghouse had originally been a saloon but was converted for other use during Prohibition. (Both, courtesy of Jack Walton.)

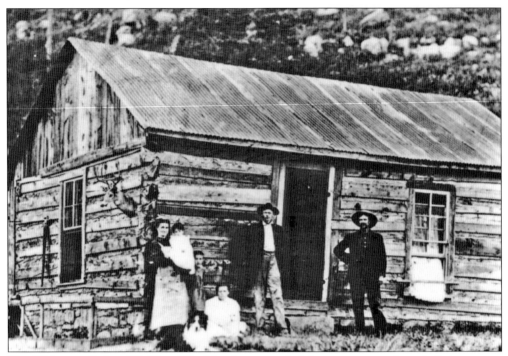

The Waltons—Robert "Rob" and Ruthie—homesteaded the extreme north end of picturesque Sugarite Canyon just over the Colorado state line around 1904, years before full-scale mining began in Sugarite Coal Camp in 1912. Above, Ruthie appears in her apron with a babe in her arms. Note the deer head mounted on the side of the cabin. In 1941, the year the coal camp closed, torrential rains caused the earth to slowly give way under the hillside cabin. The home was destroyed, and the family had to relocate. The image below proves that riding around on horseback did not stop Ruthie Walton from going in style. The unidentified girl with a parasol adds a whimsical note to this scene. (Above, courtesy of Jack Walton; below, courtesy of Robert G. Walton.)

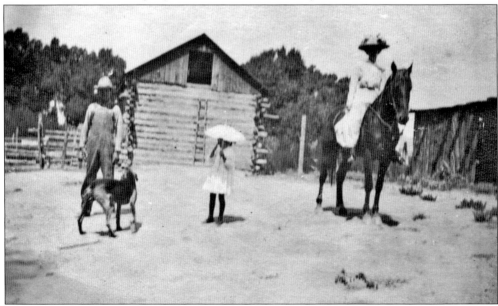

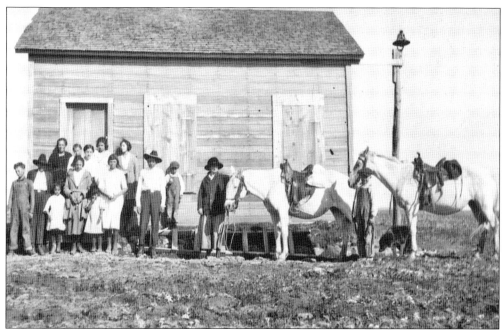

Sugarite Canyon homesteader Ruthie Walton, shown above wearing a large hat and standing next to her horse, served on the board of the Barela Mesa School, located just over the state line in Colorado. Her son Millard holds the second horse. This building was the first Barela Mesa School, shown here in the early 1920s. The people gathered by the school door are believed to be members of the Dominguez family. The boy on the far left is Joe Redlick, and the girl in the center front wearing a white dress is Mary Redlick. Note the school bell to the right of the building. Below, city relatives visit the Walton homestead as apron-clad Ruthie watches at far left. (Above, courtesy of Robert G. Walton; below, courtesy of Jack Walton.)

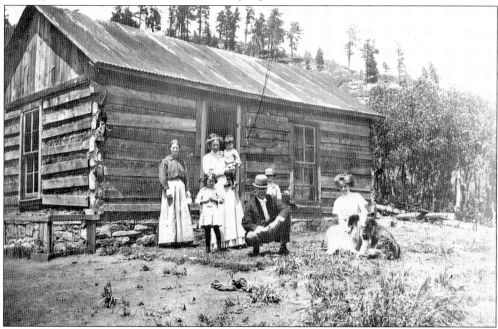

Robert H. "Buster" Walton, son of Rob and Ruthie Walton, shows off his cowboy skills by perching atop his horse. Horses played an integral role in early farming and ranching in the area. Below, haying required effort by man and beast at the Walton homestead, on the north end of Sugarite Canyon just across the Colorado state line. This photograph from 1906 shows Buster's father, Rob, sitting atop a huge wagonload of hay while fellow homesteader and neighbor "Mr. Lilly from down by the lake" stands by on horseback. The name "Lilly" is probably misspelled, as there was a nearby homestead of John Lillie and his family. (Left, courtesy of Jack Walton; below, courtesy of Robert G. Walton.)

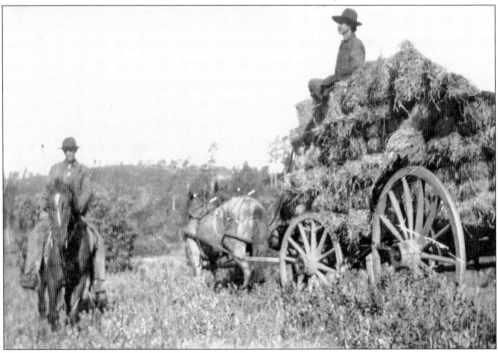

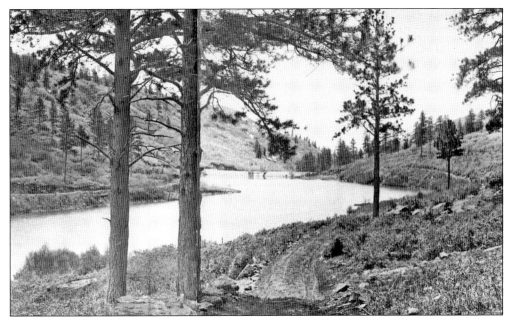

Ponderosa pines grace the shoreline of Lake Alice, built in 1892 by the Atchison, Topeka & Santa Fe Railway. Sugarite Coal Camp residents used lake water for bathing, laundry, and household chores, while using nearby springs for drinking water. In winter, ice was harvested from Lake Alice for refrigerated train cars and for family ice boxes—the forerunners of modern refrigerators. The New Mexico Museum image below, used in a *New Mexico Magazine* calendar, shows workers cutting ice on Lake Alice in 1906. One story says that a team of horses once broke through weak ice on the lake and drowned. Lake Alice was named after Alice Jelfs, the daughter of a prominent Raton banker at the time. (Above, courtesy of the Raton Museum Collection.)

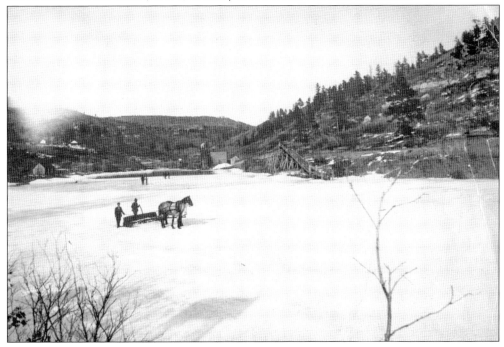

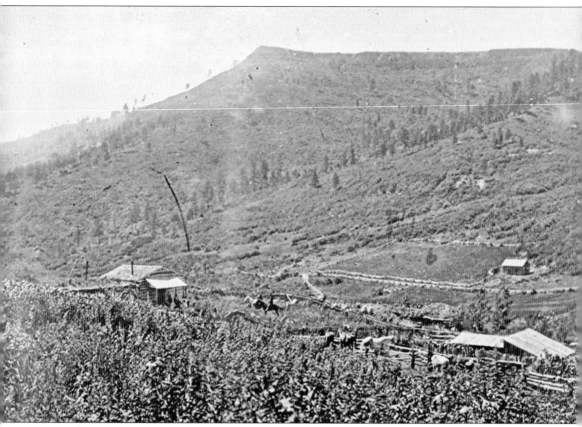

This bucolic scene shows the homestead of John and Cynthia Lillie, located in the valley that would become the site of Lake Maloya in Sugarite Canyon. Here people stand on the cabin porch, and two others perch on horseback nearby. Note the horse corral and fenced fields. The Lake Maloya dam would be built in 1907, leaving any remains of the homestead underwater. Lake Maloya was created when the nearby town of Raton and local railroads needed more water than could be supplied by two other existing lakes in the canyon. These reservoirs allowed mine operators to spray water in the mine tunnels or adits to keep down explosive coal dust. And Sugarite Coal Camp residents had plenty of lake water for their bathing, laundry, and housekeeping chores, as well as places to fish.

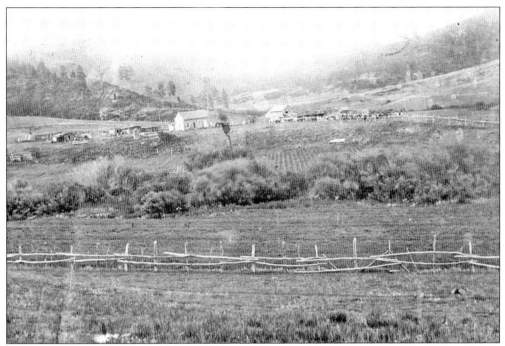

This early homestead, owned by John and Cynthia Lillie, was situated on the future site of Lake Maloya, which was created in 1907. This photograph looks north, and the two mesas in the background are across the state line in Colorado. In the "after" shot below, Lake Maloya is the image of tranquility. Note the same two mesas in the background. The boat dock area at lower left no longer exists. Some three miles downstream, Lake Alice was the first lake built in the canyon in 1892. The lakes provided water and fishing spots for the residents of Sugarite Coal Camp during its existence from 1912 to 1941. Both lakes remain popular fishing destinations to this day as part of Sugarite Canyon State Park. (Below, courtesy of Robert G. Walton.)

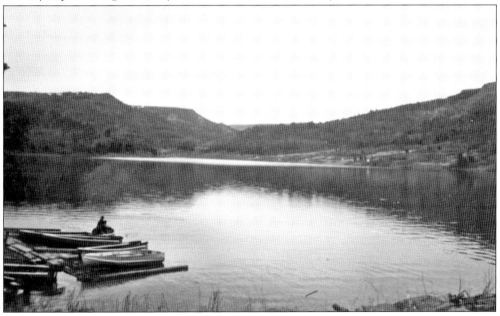

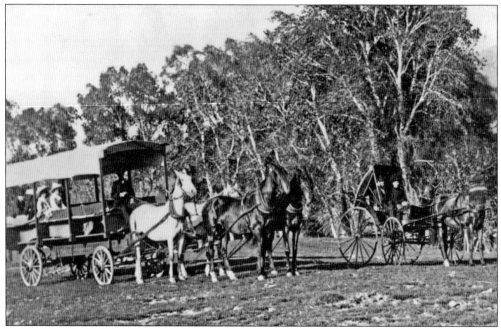

Early visitors to Sugarite Canyon ride in style in a covered passenger wagon pulled by four horses. The women sport big hats to protect their skin from the sun. The wagon is accompanied by a two-person buggy. Trees, likely cottonwoods, stand in full leaf in the background, indicating that the photograph was taken in the summer.

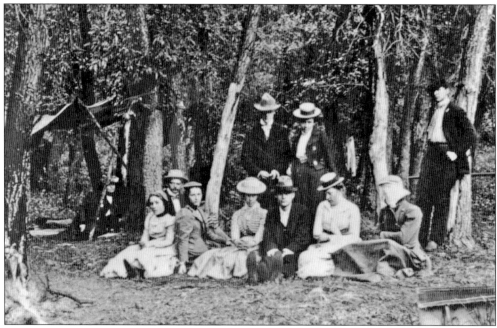

Eleven people visit Sugarite Canyon for a picnic, probably in the early 1900s. The woman seated at far right has her face obscured, possibly by a wind-whipped scarf. Notice that two of the other women wear boaters, straw hats with ribbon bands. These hats were worn by both men and women at the turn of the 20th century.

Two

Birth of a Coal Camp and Swastika Coal

Small-scale coal mining in Sugarite Canyon began around 1900 with a wagon mine. Area residents would drive their horse or mule wagons into the canyon and drive away with a wagonload of coal for heating their homes and cooking their meals.

That changed when the St. Louis, Rocky Mountain & Pacific Company came on the scene, quickly ramping up mine operations. Around 1912, the company began building Sugarite Coal Camp as an organized community complete with a school, clubhouse, and company store.

Immigrants from about 19 nationalities and speaking at least seven languages were drawn to the coal camp as an opportunity to come to the United States. The coal they produced heated homes as far away as Nebraska.

Some of that coal carried what at the time was an impressive brand: Swastika. For centuries, the swastika had been used like a rabbit's foot to symbolize good luck and good fortune around the world, from churches in Ethiopia to temples in Korea to road signs in Arizona. Of course, the Nazis changed all that.

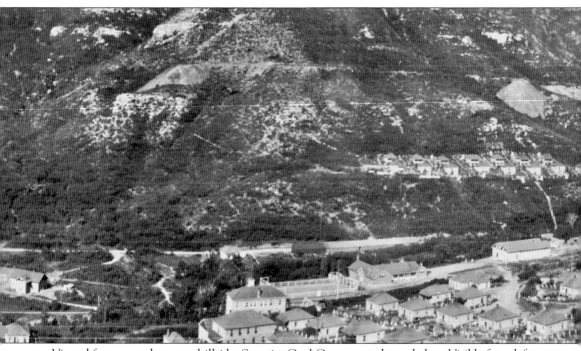

Viewed from a southeastern hillside, Sugarite Coal Camp spreads out below. Visible from left to right are the two-story school, the athletic field, the clubhouse, and the company store. The small cluster of houses on the hillside in the background represents the elite neighborhood of Scotch Hill, where mine bosses lived apart from regular miners. Many of those bosses hailed from Scotland

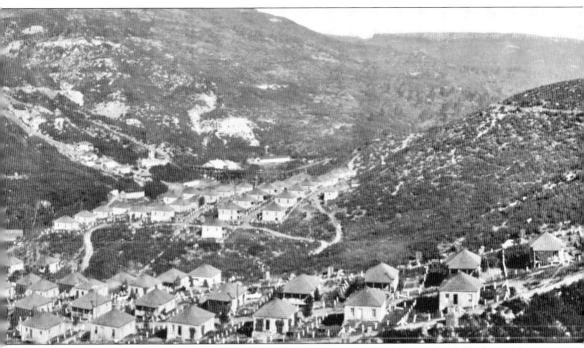

and Wales. Homes of regular miners with their white fence posts trudge up the hillsides on the left. To the rear is the neighborhood known at the time as Jap Hill, where miners of Japanese and other ethnicities lived. Behind this cluster of homes, the long, pale building is the mule barn, which still stands and remains part of park operations in Sugarite Canyon State Park.

In 1915, Jim Sayr prepares to hike uphill to one of Sugarite's three mines with his lunch bucket and a small oil lamp on his work hat. Sayr stands before an outhouse, provided for every home. While there was no indoor plumbing, every two houses had access to a spigot that provided lake water for household chores. Boys fetched spring water for drinking. (Courtesy of the Raton Museum Collection.)

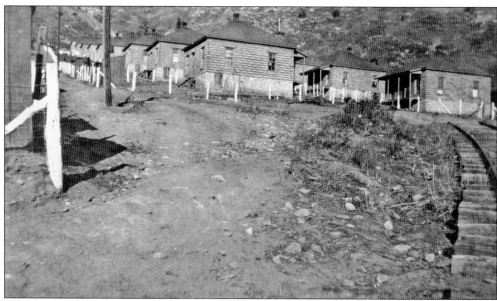

Block houses march neatly uphill in Sugarite Coal Camp. The 20-by-20-foot, four-room homes were surrounded by wire fences with white fence posts, and each home had its own outhouse. Although the houses appeared to be made of stone, they were mostly made of coke block with a cement facade. Each house had a front porch as well as a cellar for food storage. (Courtesy of the Raton Museum Collection.)

This little suspension bridge allowed coal camp residents to walk across Chicorica Creek, which runs the length of Sugarite Canyon. The origin of the name "Chicorica" is unclear and possibly stems from Comanche or Spanish. One theory suggests it combines Spanish words for "little" and "rich," which would be an apt description of Sugarite Canyon and its wealth of natural resources. The name "Sugarite" is likely a mispronunciation of Chicorica.

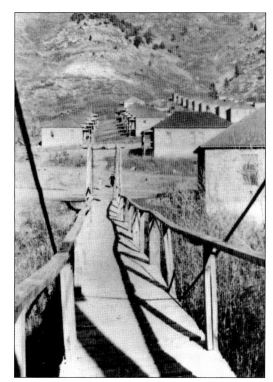

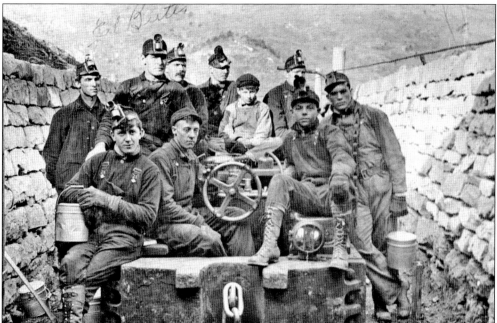

Clean-faced miners preparing for work in 1918 cluster around an electric tram at a Sugarite mine entrance. Boys went to the mines after finishing elementary school. The miners carry lunch buckets and wear headlamps. The only miner identified is Ed Butts, at far left. He married Margaret (Mary) Ross. He and their eight-month-old son, John, died in the 1920 flu epidemic. (Courtesy of the Raton Museum Collection.)

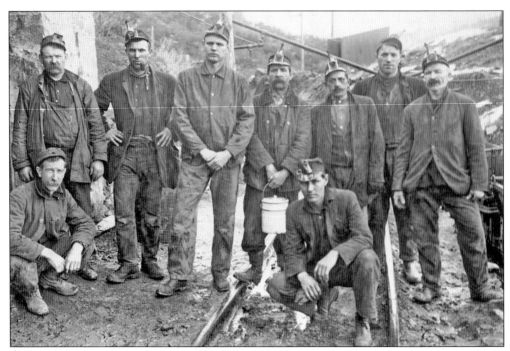

Grim-faced Sugarite miners prepare for their shift. The small oil lamps on their caps indicate the photograph was probably taken before 1920, when most miners switched to carbide lamps. Commonly referred to as "teapot lamps," the oil lamps resembled a small kettle, fueled by a wick stuffed into the spout. This early form of lighting meant that the miners actually worked with an open flame on top of their heads—a scary proposition in tunnels possibly containing methane gas. (Courtesy of the Arthur Johnson Memorial Library.)

		Year 1913	Dec. 1919	Percentage of Increase
Trappers, (Boys)	Per Hour	$.1625	$.435	167.7
Knucklemen	Per Hour	.2275	.56	146.2
Switchtender, (Boy)	Per Hour	.16 2-3	.39	134.1
Oiler, (Man)	Per Hour	.2275	.525	130.8
Coupler, (Man)	Per Hour	.2275	.525	130.8
Tippleman	Per Hour	.2275	.525	130.8
Blacksmith Helper	Per Hour	.25	.55	120.0
Car Repairer	Per Hour	.30	.65	116.7
Dumpers	Per Hour	.2775	.575	107.2
Shot Firers	Per Hour	.425	.88	107.1
Car Droppers	Per Hour	.29	.59	103.4
Blacksmith	Per Hour	.375	.75	100.0
Electrician Helper	Per Day	2.50	4.95	98.0
Drum Runners	Per Hour	.3325	.65	95.5
Motormen	Per Hour	.3875	.75	93.5
Timbermen	Per Hour	.3875	.75	93.5
Tracklayers	Per Hour	.3875	.75	93.5
Drivers	Per Hour	.3875	.75	93.5
Stone Mason	Per Hour	.3875	.75	93.5
Driver Boss	Per Hour	.425	.81	90.6
Loaders of Machine Coal,	Per Ton	.35	.66	88.6
Bone Pickers, (Boys)	Per Hour	.165	.31	87.9
Dock Boss	Per Hour	.335	.615	83.5
Substation Tender	Per Month	85.00	156.00	83.5
Weigh Boss	Per Month	90.00	163.00	81.1
Fire Boss	Per Hour	.48	.855	78.1
Stable Boss	Per Month	90.00	154.00	71.1
Machine Runners	Per Hour	.50	.855	71.1
Electrician	Per Month	120.00	204.00	70.0
Mine Boss	Per Month	130.00	218.00	67.7
Mining	Per Ton	.55	.89	61.8

A Sugarite coal miner might earn less than $7 a day in 1919, according to the 12th annual report of the St. Louis, Rocky Mountain & Pacific Company. On average, a miner earned $6.84 per day after deducting various monthly expenses, including rent and electric light, $3.50 per room; doctor's services, medicine, and hospital, $2.50; blacksmithing, 50¢; and miner's electric lamps, $1.50. (Courtesy of the Arthur Johnson Memorial Library.)

Average tons per day per miner							
Months	Koeh-ler	Van Houten	Gard-iner	Swas-tika	Bril-liant	Sugar-ite	Total Average
August, 1919 _____	8.3	9.3	7.6	5.9	7.8	7.9	7.8
September _____	8.0	8.0	7.7	5.2	8.0	7.8	7.5
October _____	9.1	9.1	7.4	7.1	7.2	7.4	7.9
November _____	9.5	8.5	7.9	7.0	6.9	6.2	7.7
For the 4 Months____	8.7	8.7	7.6	6.3	7.4	7.3	7.7

In 1919, a Sugarite miner wielding a pick and shovel could produce an average of 7.9 tons of coal per day—nearly 16,000 pounds! This account, compiled for the 12th annual report of the St. Louis, Rocky Mountain & Pacific Company, shows average daily production from August to November 1919 by miners in six company camps: Koehler, Van Houten, Gardiner, Swastika, Brilliant, and Sugarite. (Courtesy of the Arthur Johnson Memorial Library.)

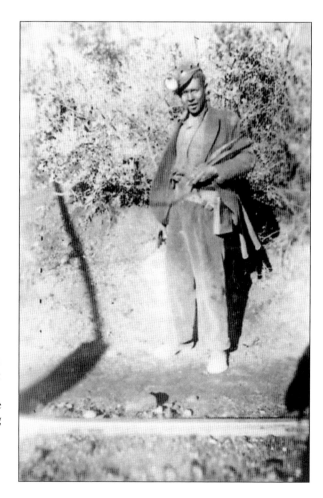

A lone Sugarite miner pauses with two picks slung over his shoulder. Miners at the camp had to buy their own tools, and some pounded their initials into the metal of their picks. Miners leaving for work carried all their gear straight up the hill, including a shovel for scooping up salable coal. Lunch buckets also constituted crucial equipment to keep the men energized for the brutal physical work.

This man, identified only as "Dad" Wagner, served as the night watchman for Mine 2 at Sugarite Coal Camp during World War I. Here Wagner appears to be headed to work, brandishing a handgun apparently used to ensure no shenanigans on his watch. A careful look indicates a child might be behind Wagner, holding onto the dog. It is unclear why the mine company would have used a night watchman, unless it was to try to prevent miners from stealing company dynamite. Mining lore suggests that at some coal mines, miners would try to steal dynamite to reach additional coal. It is unknown if this happened at Sugarite, where coal miners were only paid for the salable coal they brought out. If they ran out of coal in their assigned tunnel or adit, they were done for the day, no matter how much they had earned.

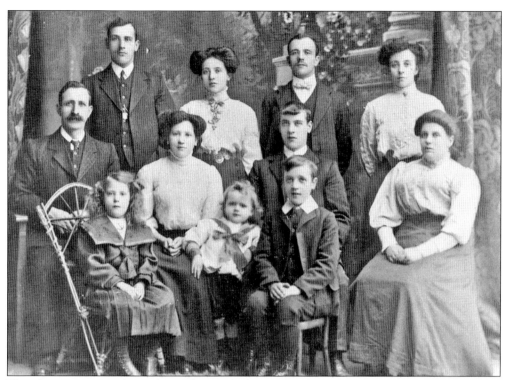

The elegant portrait above shows the Bartholomew family in their home country of England, probably around 1910. Patriarch John Bartholomew and his wife, Catherine, are pictured with their nine children. A few years later, he and members of his family immigrated to Sugarite Coal Camp in remote New Mexico. From left to right are (first row) youngsters Lillian, Charles, and Thomas; (second row) John, Gertrude, James, and John's wife, Catherine; (third row) Richard, Mabel, George, and Catherine Marie. Below, clean-faced men of the Bartholomew family pause before work around 1915 at one of Sugarite's sister coal camps. Armed with lunch buckets and tools, these miners enjoy a last smoke of their pipes and cigarettes. From left to right are Dick, Tom, and Jim Bartholomew, along with their father, John. (Both, courtesy of Dorothy Kay.)

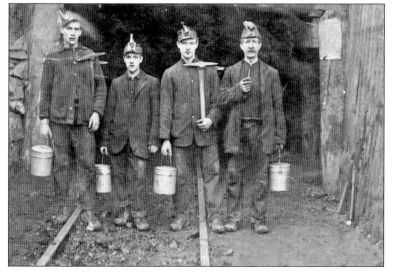

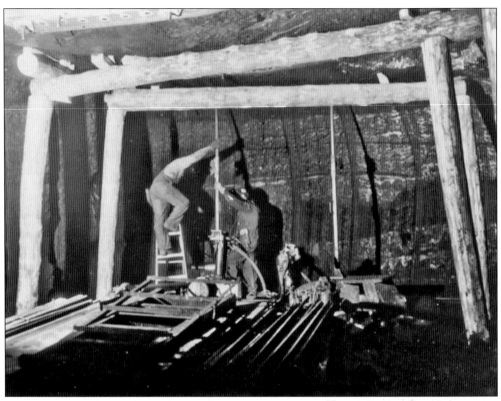

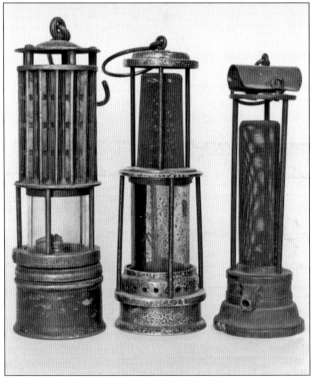

Here, miners at Sugarite's sister camp of Koehler install timbers to stabilize the roof of the adit. The same method was used at Sugarite. At night, the dynamite crew would blast. The next day, miners used picks and shovels to get at chunks of salable coal. Using the room and pillar method, columns of coal would be left to support the roof. Eventually, timbers would replace those columns.

Safety lamps such as these helped officials check air quality inside the Sugarite mines before a shift crew entered. Typically, the fire boss was the first to enter a mine, watching the live flame in his lamp. If the flame level was too low, this indicated a lack of oxygen. A flame too high indicated too much methane gas. In some lamps, the flame was protected by shatter-proof glass.

30

This miner's helmet is made of rawhide hardened by a coating of Bakelite, an early version of plastic. This helmet marked an advance from those of canvas or rawhide. The headlamp, fueled by carbide gas, provided good light. However, carrying a flame on one's helmet was not desirable around flammable methane gas, so Sugarite miners quickly shifted to new battery-operated headlamps when they became available.

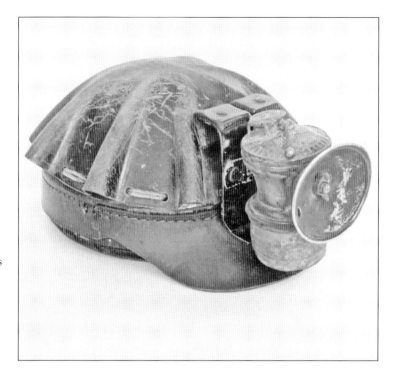

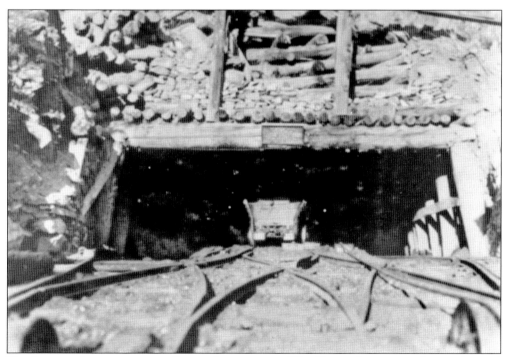

This buttressed mine entrance at Sugarite's sister camp of Van Houten features a coal car and several rail tracks leading into the adit. Large timbers and boulders were key to this construction. Similar narrow-gauge tracks were laid inside Sugarite's mines, where mules pulled coal cars on rails deep into the tunnels. Miners put identification tags on their cars of coal so they would get paid fairly.

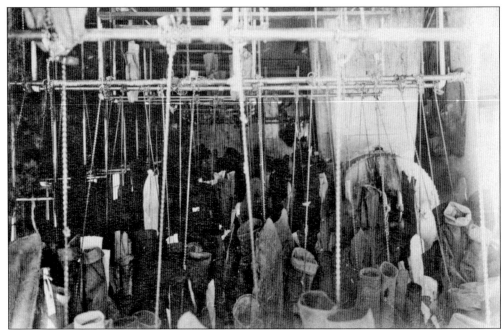

Padlocks secure chains holding assorted clothing in the bathhouse at Sugarite Coal Camp. The bathhouse, a standard feature at the camps of the St. Louis, Rocky Mountain & Pacific, allowed weary miners to wash off the coal dust and put on clean clothes before heading home. This also reduced his family's exposure to coal dust, which can cause black lung disease. (Courtesy of the Raton Museum Collection.)

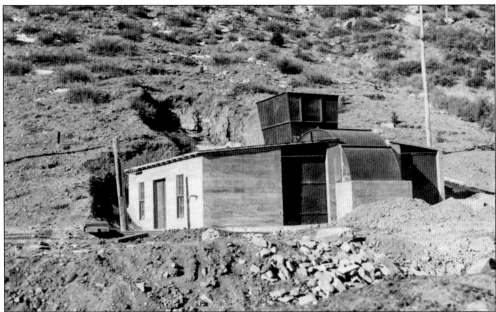

Fan houses, such as this one at New Brilliant (formerly Swastika) Coal Camp, provided a critical safety feature. A similar fan house at Sugarite blew fresh air into the adits to dissipate any flammable methane. The company also pumped water into the adits to reduce the presence of explosive coal dust. Every day, a fire boss used a safety lamp to test for unsafe levels of methane.

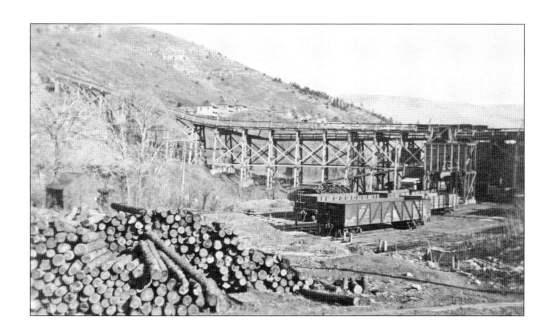

A stockpile of logs awaits use at Sugarite Coal Camp. The logs may have been used as supports inside the mine tunnels. Nearby, railcars are stationed before being pulled under the tipple to be filled with coal. A few coal camp houses can be seen on the hill behind the tipple. Below, the view looking south from on top of the tipple shows railroad cars loaded with coal waiting for transport out of Sugarite. Camp houses are visible at upper left, while the camp school building can be seen to the right. (Both, courtesy of the Raton Museum Collection.)

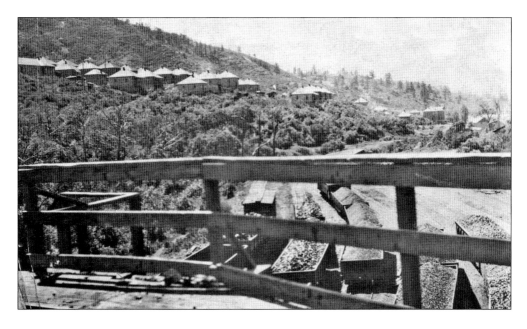

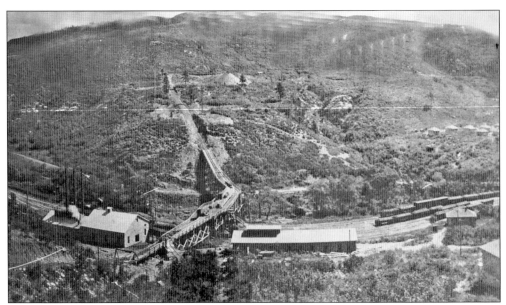

This view from high on the west side of Sugarite Canyon shows the camp's powerhouse at lower left. The tipple stretches across the canyon bottom and climbs up to Mine 2, the most productive of Sugarite's three mines. The mine area can be pinpointed by the large "gob piles" of mine waste about two thirds of the way up the east side of the canyon.

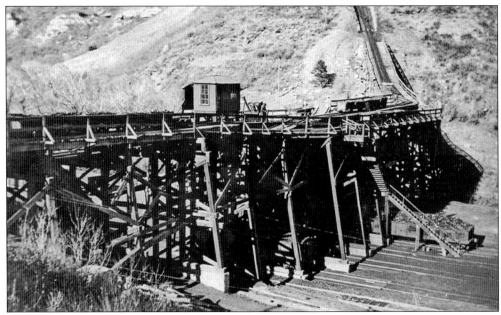

Coal cars sit atop the Sugarite Coal Camp tipple, where they will be tipped to allow coal to fall through the structure and be sorted into different sizes. Chutes channeled different-sized coal into various railroad cars. The cars were attached to a locomotive for transportation to a railroad hub in Raton some six miles away. From there, the home-heating coal was shipped as far away as Nebraska. (Courtesy of the Raton Museum Collection.)

Wooden steps reveal the towering height of the tipple in Sugarite Coal Camp. The tipple, which spanned the bottom of Sugarite Canyon, provided a staging platform for the coal brought out of the three mines. Coal was dumped from cars on top of the tipple, sorted by size, and then funneled into railroad cars below. The sign below the tipple brags that this is where "the best coal is produced."

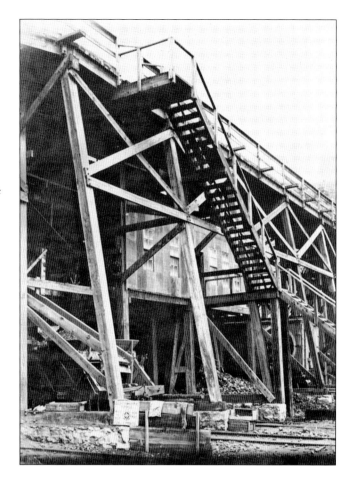

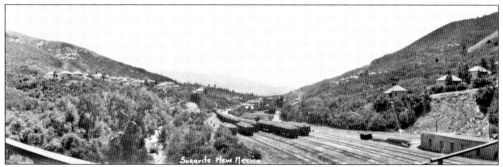

Looking south from the tipple, lines of railroad cars filled with Sugarite coal wait for transport to the rail hub in Raton, where they will be shipped to customers in states including Kansas and Oklahoma. To the right of the tracks are houses used by mine managers, who often hailed from countries such as Scotland and Wales. In the distance, Johnson Mesa provides a dramatic landmark for the region.

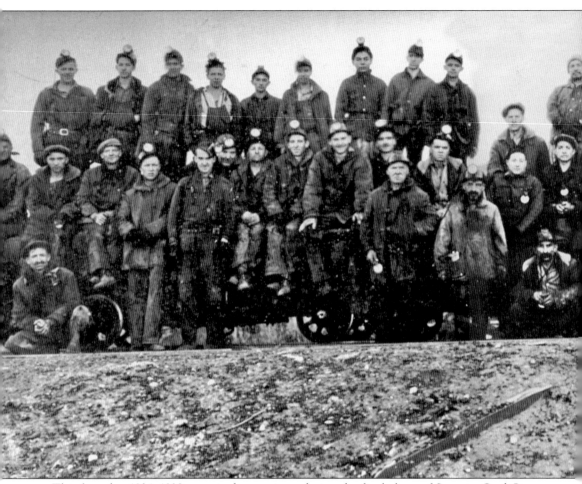

This formal c. 1934–1938 portrait shows miners during the final phase of Sugarite Coal Camp. The men wear battery-operated headlamps, the last version used at Sugarite. The lamps were powered by a large battery pack worn on belts. Miners dropped off their batteries every night to be charged, then picked them up on their way to work the next morning. Although the lamps were not as effective as previous models, they were popular, since they did not involve using an open

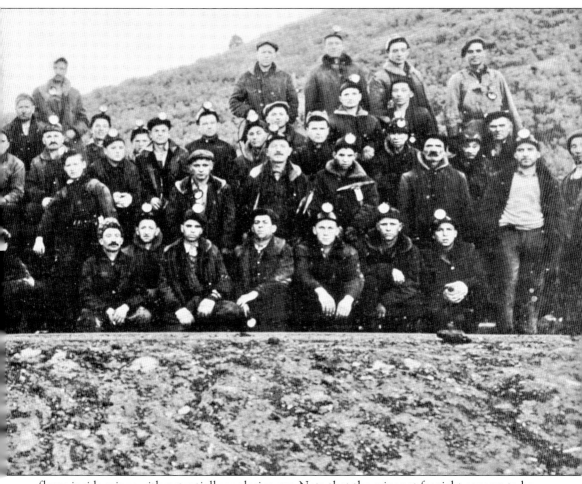

flame inside mines with potentially explosive gas. Note that the miner at far right appears to be of Asian descent. Some miners on the left of the top row seem quite young. Men wearing caps instead of helmets may have held other jobs at the mine. Clean faces indicate this photograph was taken before the men started a shift.

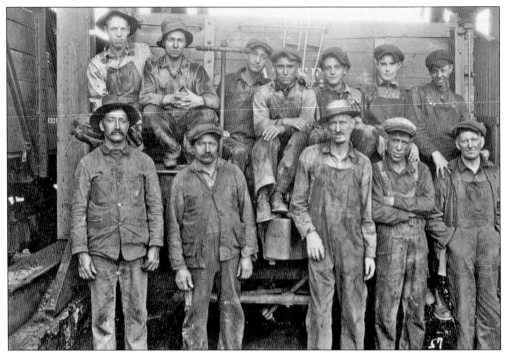

Hard physical labor took its toll on both men and boys assigned as bone pickers at the Sugarite tipple. The canyon's coal was famous for burning hot and clean, with little clinker, or waste. Bone pickers sorted through the coal at the tipple, removing lower-quality chunks. They also washed dust off the coal and used screens to sort the coal into four sizes: slag, pea, nut, and lump.

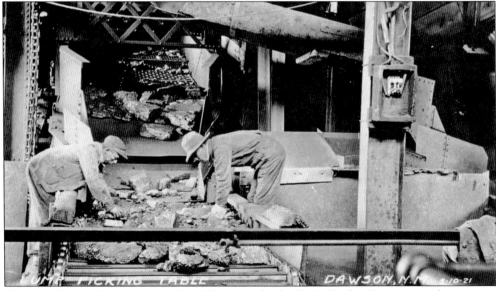

These two bone pickers at Dawson Coal Camp, run by the Phelps Dodge Corporation, demonstrate their back-breaking work. At Sugarite Coal Camp, some 40 miles to the east, bone pickers removed low-quality coal containing too much shale or "bony." The smaller company that ran Sugarite and six other coal camps in the area prided itself on selling good-quality coal. (Courtesy of the Raton Museum Collection.)

The St. Louis, Rocky Mountain & Pacific Company ran the Sugarite Coal Camp from this office. The company operated the camp from 1912 until 1941, when demand for the local coal dissipated. Mining began in Sugarite around 1902 by the Raton Coal and Coke Company, followed by the Raton Fuel Company. Customers drove up in wagons and paid to have them loaded with coal. (Courtesy of the Raton Museum Collection.)

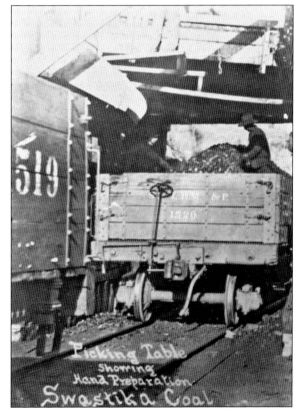

The words "Picking Table Showing Hand Preparation—Swastika Coal" describe the scene at the base of the Sugarite tipple. Coal was channeled through chutes, sorted by size, and dumped into railroad cars. These two pickers remove poor-quality coal at the last stage of production. Swastika Coal was a brand produced at Sugarite. Prior to the Nazis, the swastika was long used worldwide to represent good fortune.

The sign above boasts that this "fancy lump" Swastika coal is "high in heat, low in ash." Sugarite's coal was non-industrial but was considered of good quality for home heating and for powering train locomotives. Below, Sugarite's baseball team members of 1913 proudly wear uniforms with an S for Sugarite and the swastika logo. Summer baseball provided great entertainment in Sugarite Coal Camp. In the front row, the first man on the left is Howard Barnes, and the second man from the right is Charles E. Roundsley. The rest are unidentified. (Below, courtesy of Paula Grantham.)

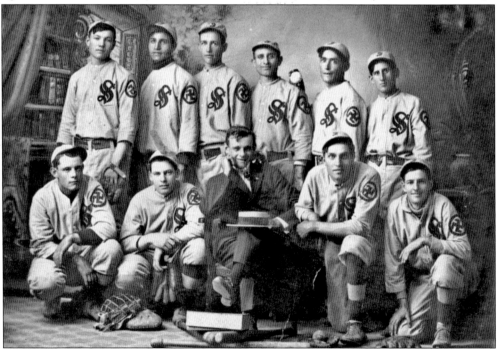

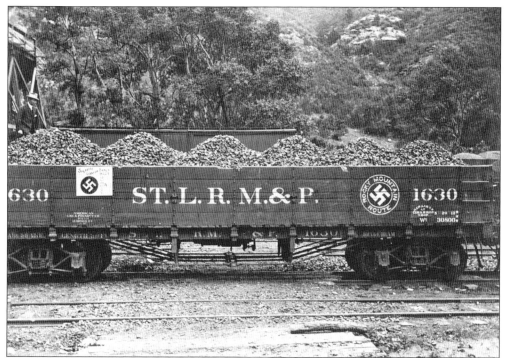

The small rail company run by the St. Louis, Rocky Mountain & Pacific Company (SLRMP) carried Sugarite coal about six miles to a rail hub in Raton. Then the coal was shipped out for home heating and to run locomotives. Below, traveling salesmen are shown around 1923 with their cars in front of the Swastika Fuel Company office in Raton. The company bought and sold coal as a subsidiary of the SLRMP. This brick building still stands on historic First Street in Raton.

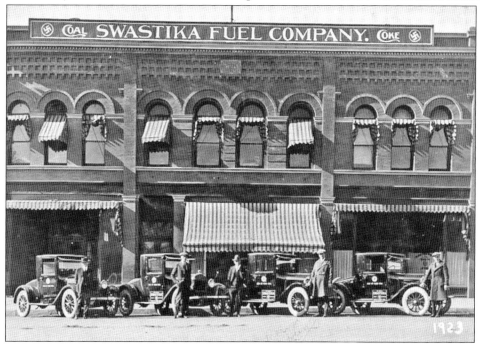

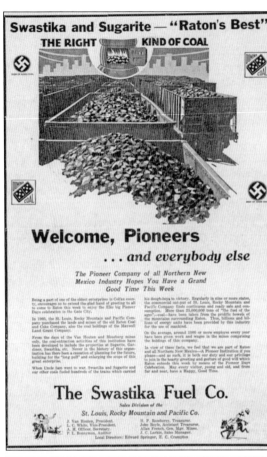

The newspaper advertisement at left for the Swastika Fuel Company ran during a 1930s Raton Pioneer Days celebration. Swastika Fuel served as the sales division for its parent company, the St. Louis, Rocky Mountain & Pacific. Here the SLRMP touts itself as a "pioneer company" that had mined more than 25,000 tons of coal near Raton. Below, the wooden tipple stretching across the bottom of Sugarite Canyon provided a staging area to get coal from cars on top to railroad cars underneath. (Left, courtesy of the Arthur Johnson Memorial Library.)

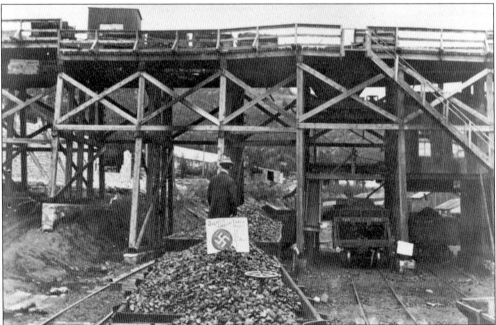

Dr. Richard Fuller served as a Sugarite company doctor, taking care of minor illnesses and injuries. Former camp resident Mary Cunja King said Fuller doled out cough syrup—green for adults and red for children. Fuller would say, "Doctors aren't here to cure people; they're here to make you feel better. God is the one who heals." Major health issues were handled at the company hospital at Gardiner Coal Camp.

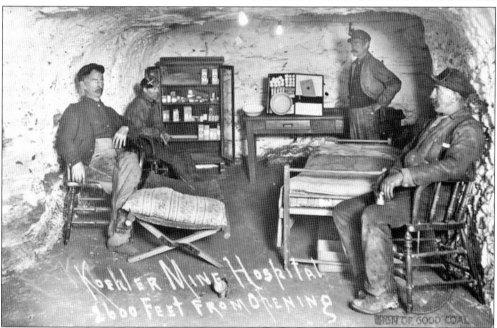

At Sugarite's sister coal camp Koehler, this doctor's office was inside the mine. At Sugarite, the doctor's office was an outbuilding near his home. Patients sat in a metal dentist's chair, and doctors relied on questionable patent medicines, commercial products containing mostly alcohol. Mexican families visited *curanderas*, women who used local plant remedies. Lacking paid sick leave, injured miners often returned to work before they should have in order to support their families.

MAN KILLED IN SUGARITE MINE

Philipi Martinez was instantly killed yesterday afternoon about four o'clock in the Sugarite mine, when he was struck by a loaded car. The accident was probably due to carelessness on the part of Mr. Martinez.

He is survived by a wife and four small children. Funeral services will be held tomorrow afternoon from the east side Catholic church.

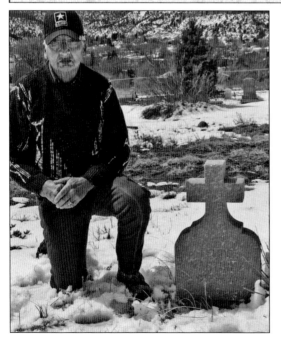

A loaded coal car ran over Sugarite miner Felipe Martinez on September 9, 1929, inside Mine 2, reportedly crushing his head. His grandson, Felipe Fresquez, pictured at left at Martinez's grave in Raton, said his grandfather was between two men pushing a loaded coal car when it came loose. The *Raton Reporter*, which misspelled Felipe's first name, refers to his probable "carelessness." Company officials routinely blamed accidents on the miners. Martinez left behind his pregnant wife, Flora, and four children. With no means of support, Flora placed her children with others. Her baby was adopted, but she reclaimed her other children four years later when she remarried. Other recorded fatalities at Sugarite include Laverna Gayet in 1934, Junichi Aoki in 1936, and Louis Short in 1938. (Above, courtesy of Colfax County archives; left, photograph by Patricia Veltri.)

Three

I OWE MY SOUL

Sugarite miners were paid based only on the salable coal they produced. On a good day in the 1930s, a miner might produce about five tons, or 10,000 pounds. For that, he received about a dollar a ton.

In the Depression, $5 a day was good money. But there was a catch. Sugarite's coal was used mainly for home heating, a demand limited to colder months. Since the Sugarite mines operated based on demand, most of the miners were laid off during the summers. During that period, they often went into debt at the company store. Come winter, they would work to pay off that debt.

The bottom line is that the miners at Sugarite never got far ahead financially. They paid the company monthly rent to live in the company houses. They had to buy their tools at the company store. Often they were paid in scrip, company money only good at the Sugarite mercantile.

But the butcher at the company store took pity on the poorest families, giving them less desirable cuts of meat like liver and tongue. Meanwhile, the resourceful miners and their families hunted and fished in the bountiful canyon, grew vegetable gardens and fruit trees, and raised chickens and rabbits.

And although one girl is said to have stood on her family's porch to complain loudly about a steady diet of soup, as far as the authors know, no one went hungry.

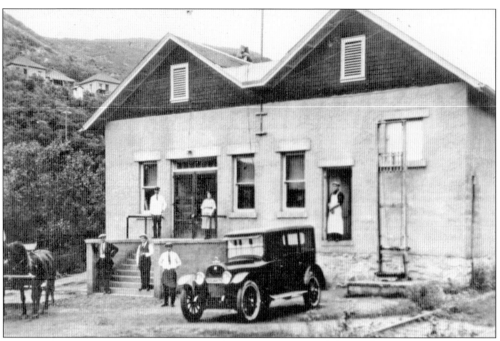

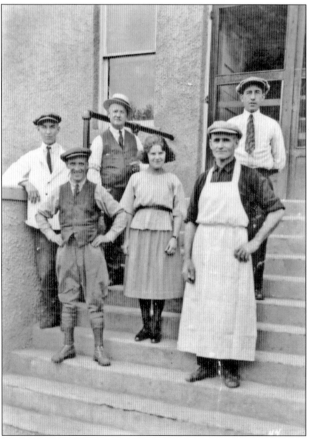

A horse-drawn wagon and an early automobile share space outside the Sugarite company store. Miners bought their picks and shovels at the store, which also sold groceries. In the 1930s, miners earned about $5 a day during peak winter production, which was good money during the Depression. However, demand for Sugarite's home-heating coal disappeared in summertime, when laid-off miners went into debt at the store. At left, employees join camp residents on the store's concrete steps. The man in the long white apron may have been the butcher, who gave away unpopular cuts of meat to poorer families. Camp families were discouraged from shopping in Raton, where prices were cheaper. At times, the miners were paid in scrip instead of dollars. The store would give them 75¢ per dollar of scrip.

Employees stand ready at the counter of the Sugarite company store. The store provided the basics for miners and their families, selling everything from picks and shovels to flour for baking bread. Industrious wives of miners often used the colorful printed material of flour sacks to make dresses for their daughters. When miners were paid in scrip, the only place they could spend their pay was at the company store. Camp residents reduced their dependence on the store by fishing, hunting, and gardening. Below, an early photograph of the store shows that its steps were originally located on the right side.

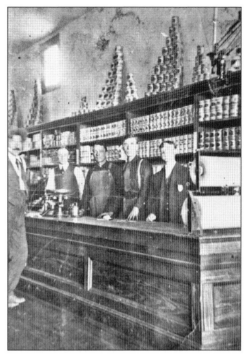

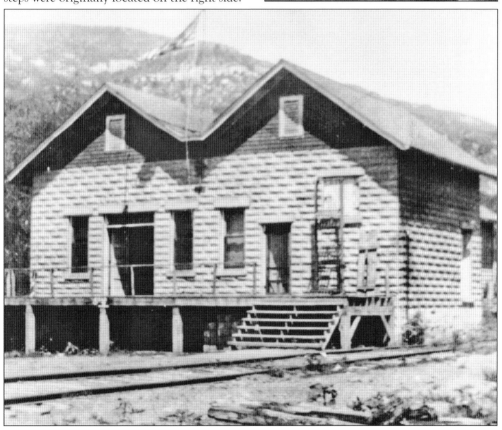

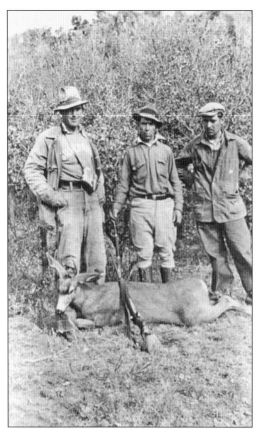

Sugarite miners were lucky to live in a canyon rich with wildlife. From left to right, hunters Philip Kuretich of Yugoslavia, Mike Terzake of Greece, and Tony Kuretich, also of Yugoslavia, display their mule deer. Mining families hunted, fished, kept chickens, grew fruit trees, and cultivated gardens to supplement mine wages. Newspaper articles from the days of Sugarite Coal Camp show that on occasion, some camp residents were accused of poaching game out of season. Below, camp residents fish at Lake Maloya, about five miles up-canyon from the mines. To this day, Lake Maloya remains a popular fishing destination and also provides drinking water for the nearby town of Raton.

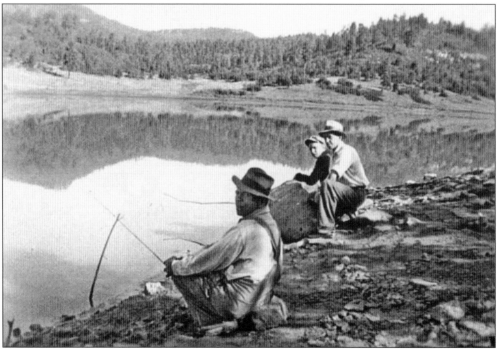

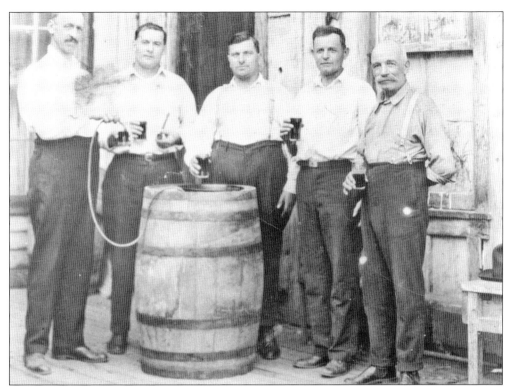

Homemade wine was popular among immigrant miners. Here residents of Dawson Coal Camp, located about 40 miles southwest of Sugarite, partake of wine siphoned from a barrel. At Sugarite Coal Camp, early miners ordered railroad carloads of grapes to make wine. One former Sugarite resident remembered that adults washed his little boy feet before he was placed in a tub to stomp grapes. His feet turned purple, creating a vivid memory. (Courtesy of the Raton Museum Collection.)

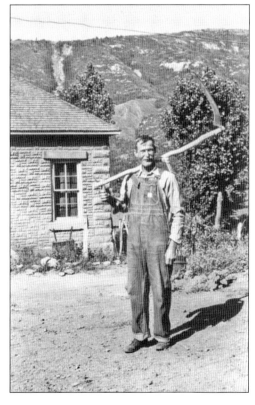

Carrying an old-fashioned scythe, Frank Kuretich Sr. pauses at Sugarite Coal Camp. Bib overalls were the fashion, and sturdy shoes were needed because of the rocky soil. Frank's grandson, who was born in the camp, later recalled that camp men like Frank Sr. did their own cobbling and resoled their shoes as needed. He also remembered that his grandfather mentored younger men in the family at the coal mine.

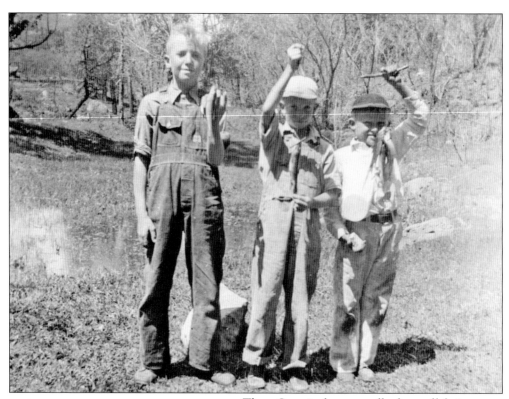

Three Sugarite boys proudly show off their catches of the day. Hugh Montgomery is on the left. The other boys are unidentified. Fishing for trout in Chicorica Creek with a handmade fishing pole, string, and hook was a favorite pastime for many of the camp's children. Fish, baked or fried, supplemented the diet of camp families, especially in summer months when work was scarce. (Courtesy of Paula Grantham.)

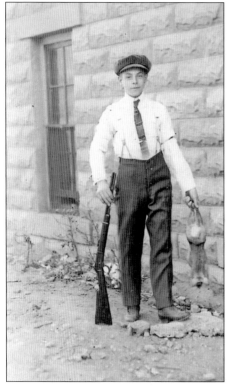

This stylish young hunter holds the rabbit he apparently shot. Mining families in Sugarite Coal Camp were self-reliant and hunted wild game to supplement their incomes. Miners earned the most in the winter, since Sugarite coal was used primarily for home heating. Many of the men were laid off in the summer, often forcing families into debt at the company store during those months.

Pictured on the steps of Sugarite's company store are, from left to right, Louie Pobar, Phil Starkovich, butcher ? West, and store manager J.G. Owensby. Former camp resident Mary Cunja King recalled that every day, one child from her family would trek to the store for cheese, salami, and 15¢ worth of meaty soup bone. Once one of her sisters went to their porch and yelled "Every day, soup. Every day, soup. It's just like a soup line!" Their mother was not pleased. Below, diverse customers of the nearby Koehler Coal Camp store appear to celebrate the purchase of a new Indian motorcycle, possibly by a store employee. Note the well-stocked shelves, including pitchers and wash basins, lanterns, and rocking chairs. Coal camp stores also stocked canned goods, clothing, hardware, tires, gas, and oil. (Right, courtesy of Paula Grantham.)

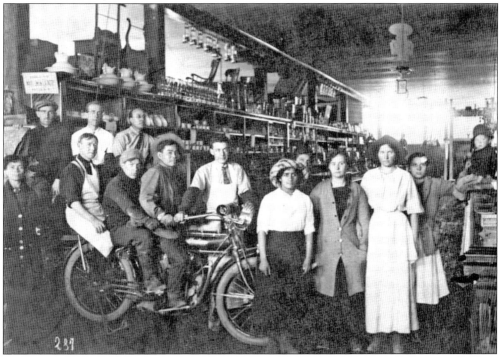

Mario Cunja (pronounced SOON-ya) holds a rabbit outside his family's Sugarite home. His Slovenian parents, Anton and Antonia Cunja, raised rabbits and chickens, grew fruit trees, and planted a garden every year. Occasionally, they purchased and processed a fresh slaughtered hog from a nearby farmer. Mario's sister Mary Cunja King said she and her siblings did not always appreciate the "simple, nourishing meals" provided by their parents. (Courtesy of Paula Grantham.)

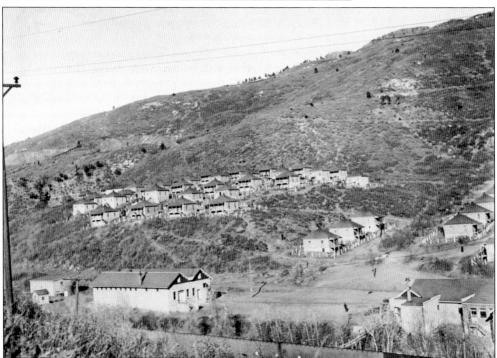

The coal camp neighborhood shown at center was known as Jap Hill. Although in general Sugarite was not segregated, it appears that most of the Japanese miners and their families lived in this area. *The Sugarite, New Mexico Story*, a 1964 account by Catholic priest Fr. Stanley Crocchiola, states that in 1912, about 50 Japanese men worked at the camp. Japanese families once imported seafood to host a dinner for Raton community leaders.

Four

MULES, TRAMS, AND TRAINS

Sugarite Coal Camp ran on different kinds of power. There was brute manpower—muscles hardened by day after day of swinging picks and shoveling literal tons of coal. But once a coal car was filled with about 2,000 pounds, other forces came into play.

The mule hitched to the car then hauled the ton of coal along narrow-gauge rails to the mine entrance. This could be a lengthy trip—one mine had 11 miles of tunnels.

At the mine entrance, the mule was unhitched, and the full car joined others hooked to a small electric tram. Tram engineers sat atop this locomotive and ran it on narrow-gauge tracks from the entrance to a wheelhouse at the hill's edge.

There, workers attached six loaded coal cars to a thick metal cable running through two big wooden wheels that were part of a gravity-powered pulley system. The cars were lowered down the hillside on tracks to the tipple at the canyon bottom. A brakeman sat in a wooden tower to ensure the loaded cars did not go down too fast, possibly flying off the tracks. The weight of the loaded cars brought up six empty cars, all powered by gravity.

Down on the tipple, each loaded car would be tipped over a hole. Coal fell through the hole and was sorted by size. Different sized coal was channeled into different railroad cars. The railroad cars then were attached to a regular locomotive and shipped out of the canyon.

Sugarite's system meant that mules played a key part in the operation. The mule barn, where the animals slept at night, had 40 "fireproof" stalls, possibly made of asbestos. The position of stable boss was critical and relatively well paid. The animals had to be fed, watered, and cared for.

Meanwhile, electricity for the trams came from across the state line in Colorado. It not only powered the trams but the camp houses as well.

Finally, the trains that hauled the coal out of the canyon were themselves powered by coal, which they burned to create steam.

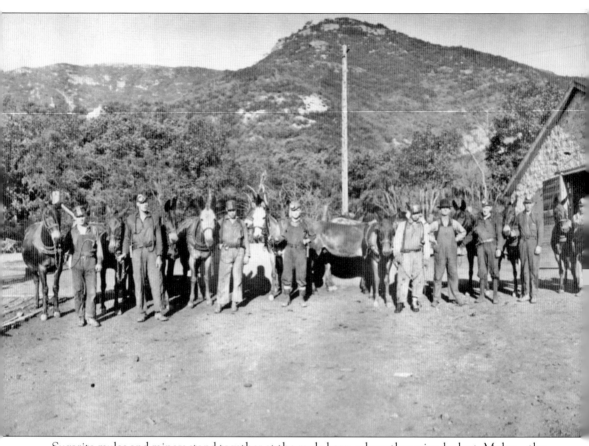

Sugarite mules and miners stand together at the mule barn, where the animals slept. Mules—the offspring of horses and donkeys—were critical workers. Inside the mines, mules pulled cars loaded with a ton of coal. Although electricity powered camp homes and narrow-gauge trams, no electricity was used inside the mines. Apparently, the company wanted to avoid possible

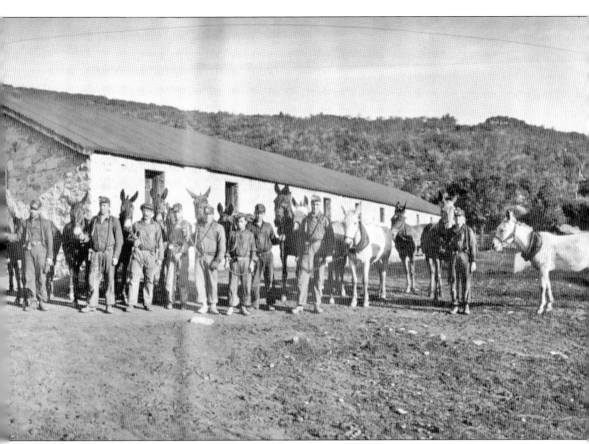

explosions of methane gas. The camp's stable boss had to pick the right-sized mule for smaller tunnels, because if a mule's ears touched the ceiling, it would not enter an area. At the end of the day, men released the animals to run downhill to the barn. The stable boss would have a full water trough waiting, because the mules would not have had any water all day.

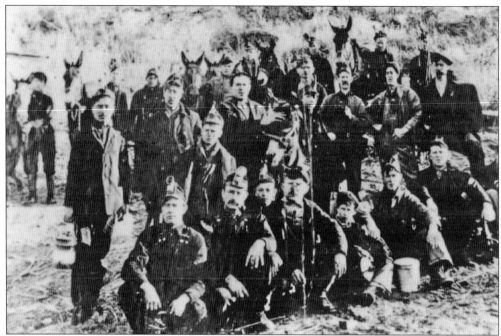

Dirty faces indicate these miners posed after a shift in Sugarite Coal Camp mines. Notice the age range—boys headed to the mine after finishing eighth grade. Two kinds of headlamps are visible: some miners have carbide lamps, while others use an earlier oil lamp or "teapot." Miners partnered with mules that hauled coal cars through miles of mine tunnels. Each car held about a ton of coal.

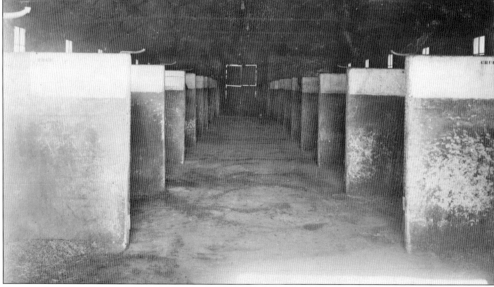

Sugarite's mules slept in these supposedly fireproof stalls. The mules were trained to run uphill to the mines each morning, possibly lured by a treat. At day's end, the tired and thirsty animals ran downhill for water and food. Often a mule sneaked into a neighbor's stall to steal food before being led to its assigned spot. Note the word "Chub" on the stall at right, possibly one mule's name. (Courtesy of the Raton Museum Collection.)

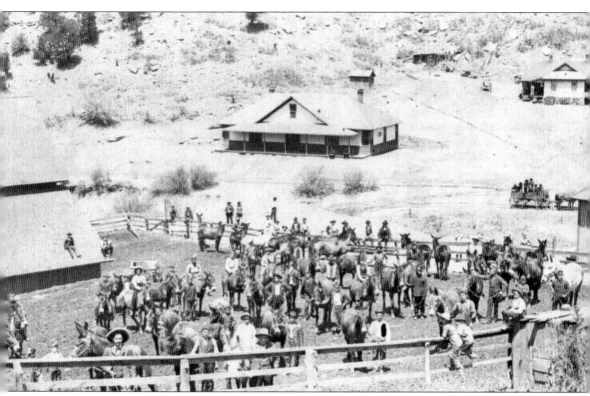

Sugarite was not the only coal camp in the area using mules, which were prized for their strength and endurance. Dawson Coal Camp, about 40 miles to the southwest, was a much bigger operation, with some 9,000 people in the community. This Dawson photograph from 1904 shows the corral holding about 40 mules. Here children cling to the rails of the corral, while other people perch on the roof of the mule barn. Note the wagon carrying people in the background. Near the front of the corral at lower left stands a *vaquero* (Spanish for cowboy), complete with sombrero and fancy jacket. (Courtesy of the Raton Museum Collection.)

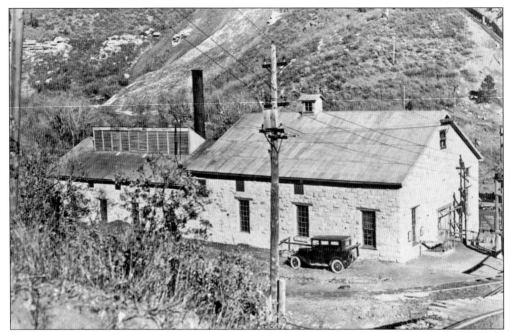

Electricity for every miner's home was an up-to-date feature at Sugarite. This building served as the coal camp's powerhouse, transmitting electricity produced by a power plant some 25 miles away near Trinidad, Colorado. According to a 1964 article by F. Stanley, the St. Louis, Rocky Mountain & Pacific Company contracted for the electricity as a cheaper alternative to building its own power plant. (Courtesy of the Raton Museum Collection.)

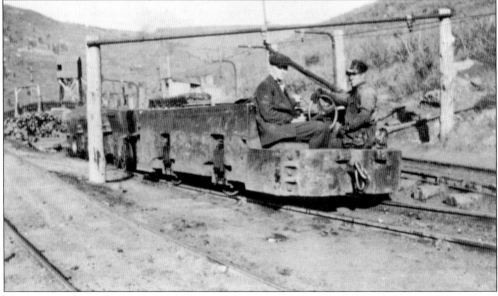

These two train engineers run a tiny electric locomotive on the mine level, some 400 feet above the Sugarite Canyon floor. The tram pulled coal cars from mine entrances to the hill's edge, where workers attached six loaded cars to a metal cable loop. Using this pulley system, the weight of loaded cars going down to the tipple staging area brought six empty cars back up to the mine level. (Courtesy of the Raton Museum Collection.)

Electric trams, similar to trolleys with overhead lines, pulled coal cars from the entrances of Sugarite's three mines to the edge of canyon walls. The cars were then attached to cables and lowered by a gravity-powered pulley system to the tipple 400 feet below. These men pose on a coal car. An electric locomotive can be seen to the left. The mine fan house stands behind them, and Little Horse Mesa is visible in the distance. Below, this well-dressed young woman poses on Sugarite's narrow-gauge tracks, probably early in the history of the coal camp, which got underway around 1912. (Above, courtesy of the Raton Museum Collection.)

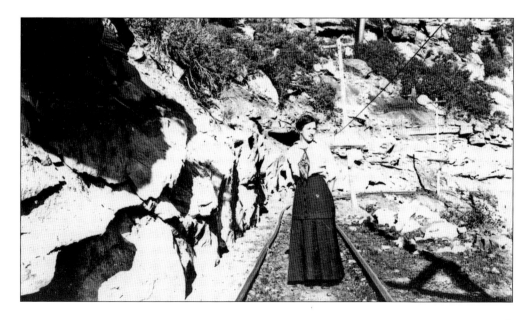

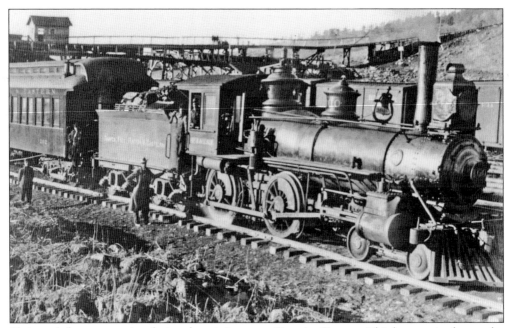

Trains ruled transportation during the mining era at Sugarite Canyon. This locomotive boasts the name Santa Fe, Raton & Eastern, a small, local rail company. The train sits at one of the region's tipples. At Sugarite, a pulley system lowered coal cars downhill to the tipple, where the coal was sorted by size and funneled into different railroad cars for shipment out of the canyon.

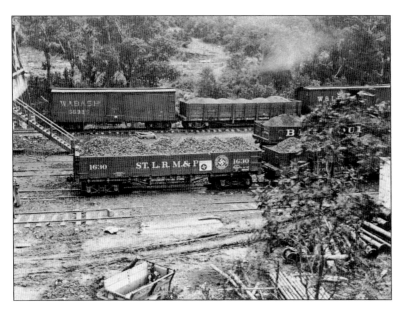

Railroad coal cars sit in Sugarite Coal Camp waiting for transport to Raton's rail hub six miles away. Note the small mine car in the foreground and two people on the far left. The railroad car in the center bears the initials of the St. Louis, Rocky Mountain & Pacific Company and the logo for Swastika Coal.

Five

THE GRAND OPPORTUNITY

Penmanship contests, spelling bees, nature walks, music, sewing, woodworking, sports, and stage performances enhanced the core curriculum of the Sugarite School, providing a well-rounded education for students from kindergarten through the eighth grade.

In September 1912, while a school was under construction, the first teacher, Catherine McLaughlin Hancock, began teaching classes in a four-room house. One room was used for the primary level and a second for intermediate students. To maintain order and discipline, McLaughlin spent her time teaching from the doorway. Teacher and pupils moved into the new school in the spring of 1913. The building included two classrooms downstairs and a library and auditorium upstairs. The auditorium was used for social events until the camp clubhouse was built. Schoolteachers provided citizenship classes for foreign-born camp residents.

In 1939, likely due to a combination of high winds and sparks from a passing coal train, a fire started in the school's belfry. Although the blaze gutted the school building, many books, supplies, and the school's piano were saved by the teachers and students, possibly with help from train workers. Classes began again the day after the fire in various empty houses in the camp.

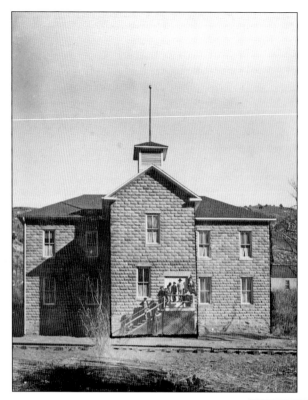

The Sugarite School takes center stage in Sugarite Coal Camp, where it was one of the largest structures. The school was also one of the first buildings in the camp, which was built by the St. Louis, Rocky Mountain & Pacific Company starting in 1912. Below, children in the first Sugarite class in 1912 reflect the camp's diverse immigrant cultures. Families hailed from Eastern Europe, Italy, Greece, Scotland, Wales, Ireland, Mexico, and even Japan. Poor coal miners and their families prized the camp's public educational opportunities for all, likely unavailable in their home countries. The school also provided English and citizenship classes. (Left, courtesy of the Raton Museum Collection.)

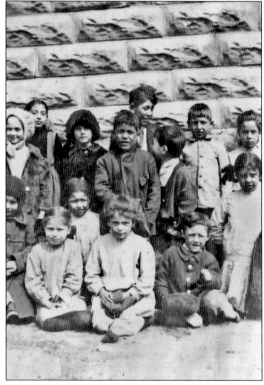

Classes began in Sugarite Coal Camp in 1912 with teacher Catherine McLaughlin Hancock, pictured here. Decades later, she recalled teaching early classes in a camp house, standing in a doorway to manage lower grades in one room and upper grades in another. Three boards painted black served as a blackboard. In 1913, a new school provided classrooms and an auditorium for camp activities. Later, those activities shifted to an elegant clubhouse.

This Sugarite School classroom features plants, artwork, learning charts, a New Mexico flag, and an artist's easel, as well as wooden desks for the teacher and pupils. Here students study under the watchful eye of teacher-principal Loren Malcom, in the back left corner. The boy in the long-sleeved sweater (third from left) is Joe Bertola, who as an adult had fond memories of the camp and often visited the town ruins.

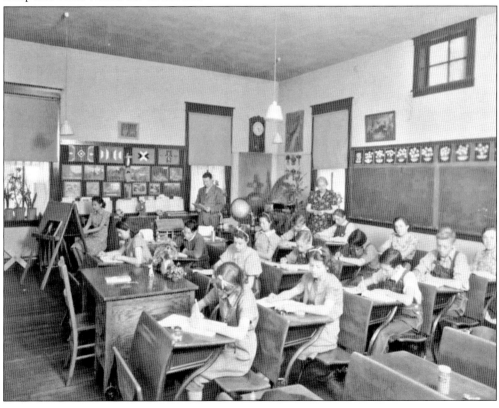

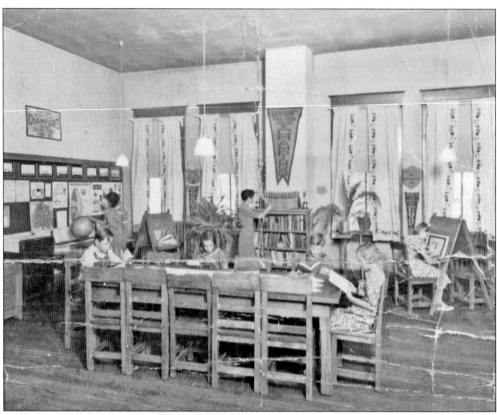

The well-furnished Sugarite School library featured potted plants, decorated curtains, art easels, and posters. The two girls on the right appear to be wearing dresses of the same floral-pattern material, which indicates their clothes may have been sewn from colorful flour sack cloth. The coal camp school not only educated the miners' children but also offered English and citizenship classes for immigrants.

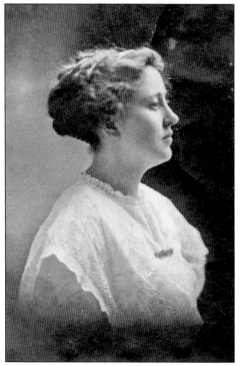

Loren Allen Malcom, remembered by Lina Giampietri Cash as a "wonderful principal," died in December 1972. According to her obituary in the *Raton Range*, Malcom was civic-minded and a member of several organizations such as Delta Kappa Gamma, Eastern Star, and Raton Garden Club. Her five sons served their country during World War II, so she earned the honor of being named New Mexico Mother of the Year.

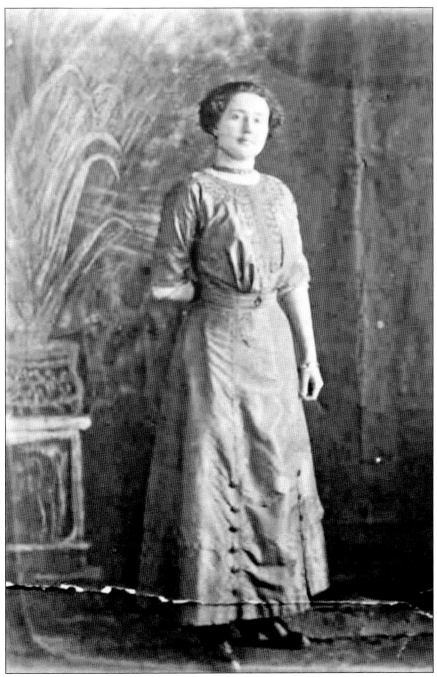

Loren Allen Malcom, a native of Bethany, Missouri, is shown at the age of 18. While residing in Colfax County, New Mexico, Malcom was a teacher and principal in Sugarite as well as in other camps owned by the St. Louis, Rocky Mountain & Pacific Company. She went on to serve as county school superintendent for eight years. Malcom later switched gears and joined the staff of New Mexico Miners' Hospital. During her time at the Sugarite School, she worked hard to acculturate foreign-born students as well as their parents. She helped children and adults learn English and provided citizenship classes for adults.

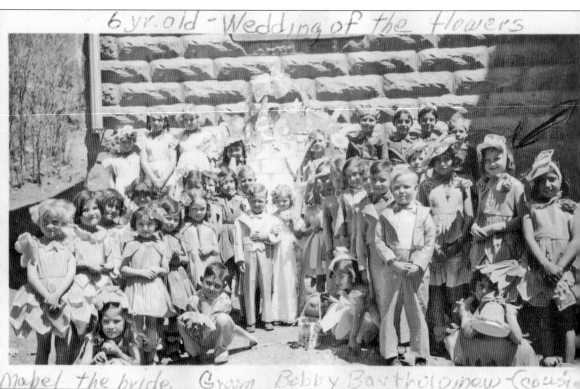

6 yr. old - Wedding of the Flowers

Mabel the bride Groom Bobby Bartholomew (cousi-

Sugarite School teachers and students staged a musical production at least once a year. Here students show off costumes for the *Wedding of the Flowers*. The elaborate costumes are a testimony to the skill and dedication of the school's sewing classes and several mothers. The six-year-old "bride" is Mabel McCormick, and the "groom" is her cousin Bobby Bartholomew. Mabel's costume was handmade by her mother, Gertrude. In another production, *The Wedding of the Painted Doll*, Sugarite's first- and second-graders performed a song-and-dance routine based on a 1929 hit Broadway song of the same name. Kindergartner Lina Giampietri Cash made it into the production when an older entertainer dropped out. The local performances included one at the elaborate Shuler Theater in nearby Raton for a convention of businesswomen. Teacher Winifred Hamilton was even invited to bring the children to perform in Santa Fe—a trip that ultimately was deemed impractical. (Courtesy of Dorothy Kay.)

Three 1930s Sugarite students appear on the school playground, possibly dressed for a school presentation. The boy on the left, Frank Rea, and the girl, Marie Giampietri, are wearing wooden shoes. The unidentified boy on the right sports a sash and clutches a wooden sword. Other students are swinging on the school swing set, indicating a recess break. (Courtesy of Paula Grantham.)

Five girls gather by the Sugarite School steps in the early 1930s with an early automobile in the background. Possibly celebrating a special event in their pretty dresses are, from left to right, Joyce McCormick, Betty Klantchnek, Berneice Baker, Emogene Kerr, and the camp doctor's daughter, Jacqueline Fuller. Each girl's ensemble included stockings, complete with wrinkles at the knees, which were similar to modern-day leggings. (Courtesy of Paula Grantham.)

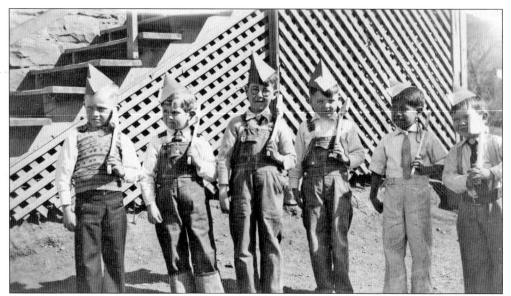

Wielding wooden hatchets and wearing folded paper hats, these boys participate in a special school program. All appear to be attired in their Sunday best. To the left are Bill Easley and Angelo Rea, who sports a new pair of overalls with the cuffs turned up. The last boy on the right is Bill Evans, likely the son of postmistress Mary Evans. The others are unidentified. (Courtesy of Paula Grantham.)

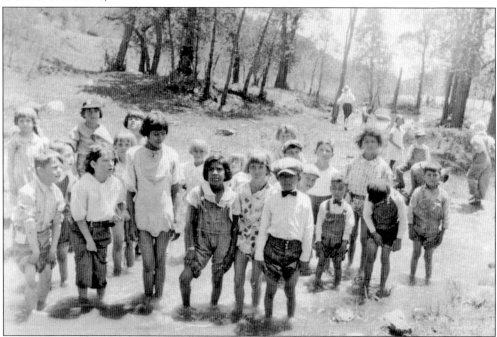

Sugarite School teachers occasionally led their students outdoors on jaunts to observe nature. In this moment of spontaneous fun, the children take advantage of the opportunity to cool off in Chicorica Creek. Being attired in school clothes did not stop them from taking off shoes and socks, rolling up pant legs, or holding up dresses to wade in the refreshing waters of the stream. (Courtesy of Paula Grantham.)

Schoolchildren mug for the camera during a nature outing. Chicorica Creek is to the left. In the back row, one boy near the left side sticks out his tongue at the photographer, while a girl to the right holds up a small fish. (Courtesy of Paula Grantham.)

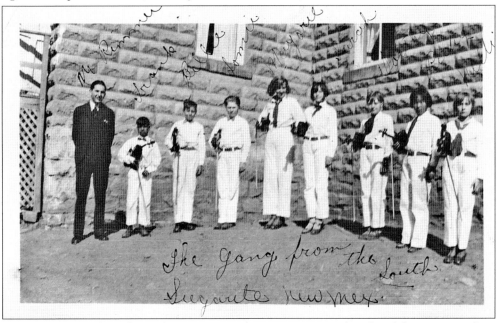

Sugarite may have been located in remote northern New Mexico, but that did not stop teachers from bringing culture to students. Here Sarah Ross, fourth from the right and daughter of stable boss John Ross, poses outside the school with teacher Mr. Rimmer and fellow members of her violin group. Hand written on the bottom of the photograph is the comment "The Gang from the South / Sugarite New Mexico." (Courtesy of Richard Newton.)

Members of Eighth Grade Class of 1939

SWASTIKA
Antonio Avila
Ambrosia Avila
Juanita Carias
George Kruljac
Eli Martinez
John Montoya
Louie Rea
Ernest Romero
Dahlia Sandoval
Jose Sisneros
Dominic Spatar
Henry Trujillo
Tony Rea
Willie Frances Hopper
Clarence Galli
Robert Evans

SUGARITE
Anna Mae Borga
Betty Klantchnek
Elizabeth Cunja
Joe Bertola
Alexander Scott
Ronald Skinner
Pete Christos
Hugh Montgomery

GARDINER
Madeline Gates
Mary Jane Vasquez
Joe Ortega
Louie Sanchez

VAN HOUTEN
Edith Bisetti
Elizabeth Chagenovich
Mary Cruz
Dolly Lucero
Eutimia Ulibarri
Robert C. Black
Kosta Kallimani
Jack Melban
Joe Rodman
Roy Rork
James Sandoval

KOEHLER
Sandina Rea
Roddy Yaksich
Joe Rea
Joe Archuleta
Chris Cruz

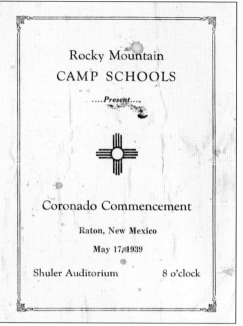

Rocky Mountain
CAMP SCHOOLS

....*Present*....

Coronado Commencement

Raton, New Mexico

May 17, 1939

Shuler Auditorium 8 o'clock

Joe Bertola's family kept this memento of his eighth-grade graduation from Sugarite School. Commencement took place at the Shuler Theater on May 17, 1939, for eighth graders from five of the camps run by the St. Louis, Rocky Mountain & Pacific Company: Swastika, Gardiner, Van Houten, Koehler, and Sugarite. In addition to Bertola, the other Sugarite graduates were Anna Mae Borga, Pete Christos, Elizabeth Cunja, Betty Klantchnek, Hugh Montgomery, Alexander Scott, and Ronald Skinner. Students performed for the audience before the awarding of the diplomas. School principals from each of the camps wrote a song or arranged a part for their students to perform. (Both, courtesy of Antoinette Bertola.)

"Turquoise Trails"

Presented by the Eighth Grades of the
ROCKY MOUNTAIN CAMP SCHOOLS

"Indian Pictures" arranged by Mrs. Loren Malcom, principal Sugarite

"Spanish Conquest," adapted and written by Mrs. Emily G. Long, Van Houten principal, and Mrs. Martha Manning, Koehler principal

"American Occupation," written by Miss Vesta Kiker, Gardiner principal, and Mr. Carroll McCleary, Swastika principal.

Music by Miss Jessie French, Music Director of Camp Schools.

The Camp Schools wish to thank Mr. Tom Murphy for the use of the Shuler Auditorium.

County Board of Education

UAL SERVIS,
County Superintendent

W. M. DENTON,
President

E. E. SALYER,
Vice-President

VIOLA K. REYNOLDS,
Clerk

T. M. UTLEY,
Member

E. A. VALDEZ, Jr.
Member

Coronado Commencement Program

I
Introduction

II
"Indian Pictures" -------------- Sugarite Eighth Grades

III
"Spanish Conquest" ----------- Van Houten and Koehler Eighth Grades

IV
"American Occupation" --------- Gardiner and Swastika Eighth Grades

Song ------------------------ "Oh Fair New Mexico"
An Appreciation ---------------- Elizabeth Chagenovich
Song, "Turquoise Trails," ----- written by Miss Vesta Kiker
Presentation of Diplomas ------------- Mr. Ual Servis
Song ------------------------ "Ride Tenderfot Ride"
"Welcome To High School" -------- Mr. Vincent Walker, Principal of Raton High School
Song ------------------------ "Tumbling Weeds"
Benediction ------------------ The Rev. Ray W. Ross
Recessional

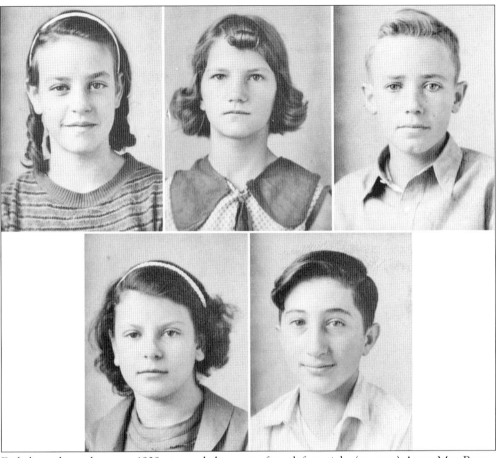

Eighth grade graduates in 1939 pictured above are, from left to right (top row) Anna Mae Borga, Elizabeth Cunja, and Hugh Montgomery; (bottom row) Betty Klantchnek and Pete Christos. The three boys below also graduated from eighth grade that year, but the only pictures available were from a younger age. From left to right are Joe Bertola, Alex Scott, and Ronald Skinner. (Above, courtesy of Paula Grantham.)

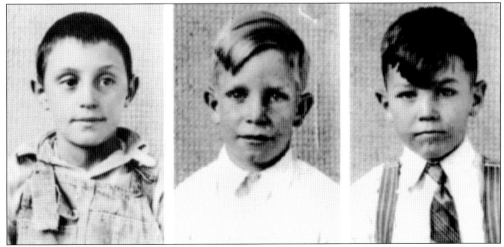

Sparks from a coal train may have triggered flames that destroyed Sugarite's school in 1939. Stories indicate railroad workers tried to pump water on the blaze from the train's boiler. Second-grader Mickey Baker watched older students and adults run inside to save books and even the piano. One story says that when two boys found some tests on a desk, one said: "Leave 'em." Classes resumed in vacant buildings the next day.

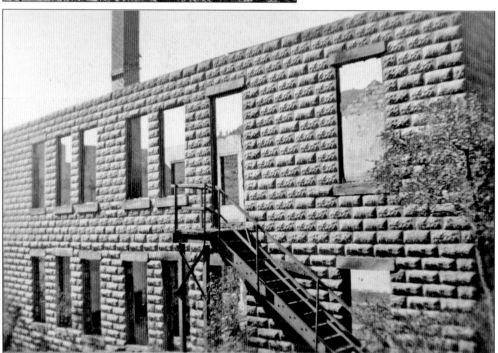

Windows and a fire escape at the back of the Sugarite Coal Camp school reveal the hollow interior left after the 1939 fire. The spacing of the windows indicates that they were located on the back side of the school library. The library had beautiful oak floors and fine wood trim around the windows. (Courtesy of Pam Hunnicutt.)

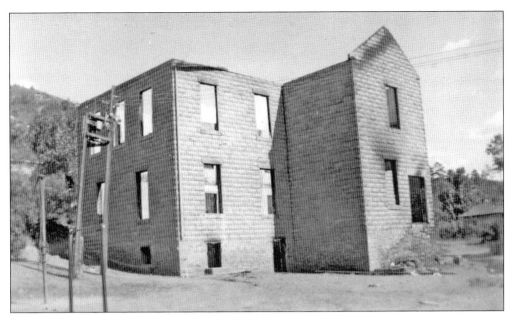

Fire gutted Sugarite School and destroyed the front steps, where many times teachers and students posed for photographs. An electric pole and wires can be seen on the side of the school. Electricity, transmitted from a power plant in southern Colorado, was a modern feature of Sugarite Coal Camp, where every house and building was wired. (Courtesy of Pam Hunnicutt.)

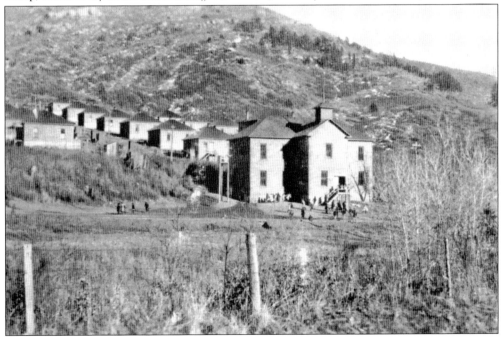

Before the fire, the school building was one of the most imposing in Sugarite, reflecting the importance placed on educating miners' children. Mining families cherished this opportunity, something usually reserved for the wealthy in their home countries. But school officials also acknowledged the value of recess, providing a playground with a slide and swings. Students also would have played jacks, marbles, tag, jump rope, kick the can, baseball, and basketball.

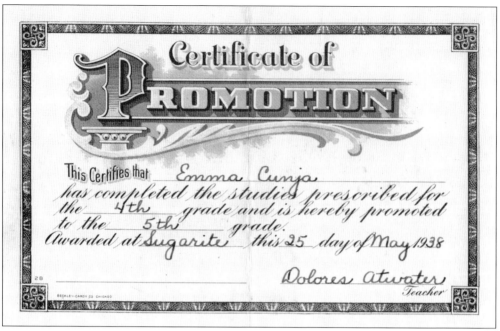

Certificate of PROMOTION

This Certifies that *Emma Cunja*
has completed the studies prescribed for
the *4th* grade and is hereby promoted
to the *5th* grade.
Awarded at *Sugarite* this *25* day of *May 1938*

Dolores Atwater
Teacher

2B

BECKLEY-CARDY CO CHICAGO

After the 1939 fire that destroyed Sugarite's school, the only things left behind were memories, photographs, and memorabilia like the piece of paper above. Teacher Dolores Atwater signed off on this certificate of promotion for Sugarite student Emma Cunja to certify that she had passed fourth grade and was being promoted to fifth grade as of May 25, 1938. Such certificates were proudly saved by poor immigrant families like the Cunjas. Below, teacher and miner's wife Leola Gates Sayr stands with some of her pupils on the front porch of Sugarite School. The students wear standard dress, including overalls and watch caps.

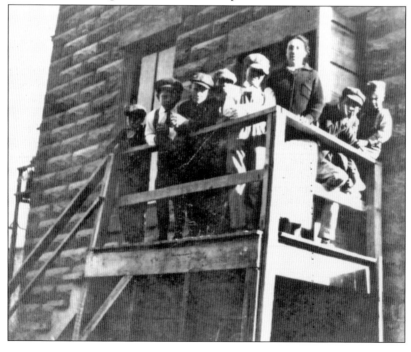

Six

WOMEN'S WORK

While men worked their shifts at the mine and then went home to rest, their wives, mothers, and sisters worked most waking hours.

The day began with the woman of the house cooking two meals—breakfast for the entire family, and lunch for the miner about to head up the hill for work. Lunch for those working men was a big meal meant to fuel them while slinging picks and shovels all day long. For some cultures, that might mean roast beef, potatoes, and bread. For others, it might mean beans, rice, and tortillas.

One miner, Angelo Recchia, built his wife an outdoor oven so that she could bake bread. And bake she did, selling loaves for 15¢ apiece. The aroma of her fresh-baked bread probably accomplished much of her marketing. Bachelor miners who lived just down the hill at a boardinghouse likely caught the smell and made some of her best customers.

Aside from cleaning and cooking, the women also sewed dresses for their daughters, often out of the colorful cloth from empty flour sacks. Women were not allowed to work in the mine, and there were few paid jobs available for females in the mine camp. Women did serve as schoolteachers and ran the company post office.

When one miner died in an accident at one of Sugarite's sister camps, his widow was left with four young sons and a fifth on the way. The company offered her a school janitorial position, and she raised her five boys on that salary.

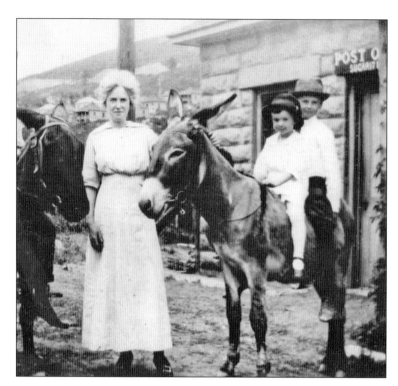

Sugarite postmistress Mary Evans steps out of her office in 1914 to spend time with her sons William (left) and Donald, perched on a mule. Sorting and delivering mail was one of the few coal camp jobs where a woman could earn a paycheck. Decades later, a relative of Mary Evans reported that she died in the flu epidemic of 1917–1918.

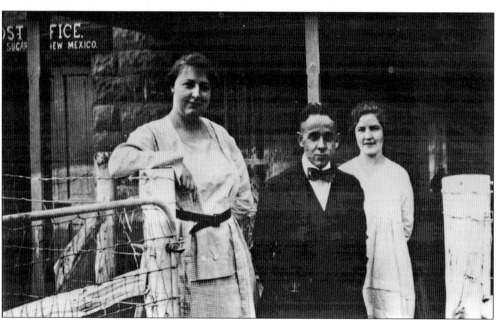

Postmistress Minnie Espie (believed to be at left) and friends stand before the Sugarite Post Office around 1921. Various women worked as postmistress of the Sugarite Coal Camp, one of the few jobs available to females. They lived and worked out of the building, one of a handful left intact when most of the camp was torn down in 1941. Today, it houses the visitor center for Sugarite Canyon State Park.

Cherished principal and teacher Loren Malcom made sure that Sugarite students received a well-rounded education that included field trips, sports, art, music, drama, and hands-on training such as sewing for girls and woodworking for boys. At the end of the school day, Malcom tutored students who needed help. At night, she taught English to adult immigrants, like coal miner Anton Cunja of Slovenia.

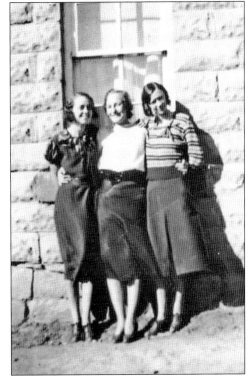

Three young women teachers enjoy a moment together near a structure that is likely the school. Their dress indicates they worked at Sugarite sometime in the 1930s. They are identified as, from left to right, Maude Carpenter Floyd, Mary Varner Neish, and Marie Pratt. Teaching was one of the few paid work opportunities in the camp. Women were not allowed to work inside the coal mine, supposedly because it was bad luck. At least in some cases, schoolteachers ended up married to young miners employed at Sugarite.

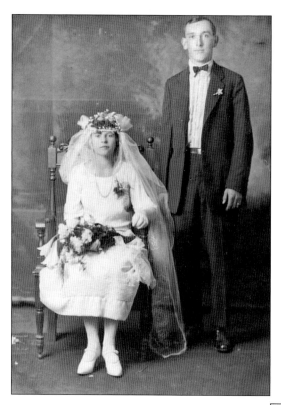

The role of wife was traditional women's work. Alex Klantchnek and Katy Srok were married around 1923. The bride was about 15 years old. The groom was a miner at Sugarite but came from a family of farmers. His father and brothers worked a homestead on nearby Barela Mesa, formerly Barilla Mesa. (Courtesy of Pam Hunnicutt.)

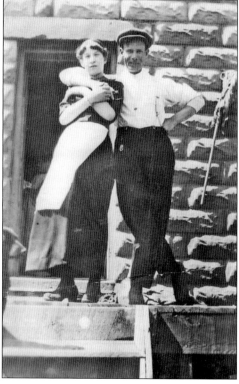

A camera caught this couple in a casual moment in 1912 on the porch of a home in Sugarite Coal Camp. Camp construction began in earnest in 1912, so this is an early portrayal of daily life. Bill Langley sports the fashion of the day. The photographer may have interrupted the work of the apron-clad woman, identified as Louis Roundsley. A mop hangs at the ready.

While men had fixed shifts, women's work never ended. Here Sugarite teacher and miner's wife Leola Gates Sayr sweeps up around her home. Women cared for children, cleaned house, and rose early to prepare two meals—breakfast plus a hearty lunch for their miner relatives. One woman baked bread in an outdoor brick oven and sold it for 15¢ a loaf to bachelor miners. Below, older sister Wanda Walton Kamm keeps an eye on her brothers Gary (left) and Robert G. Walton while the trio are part of a family outing near the upper Chicorica Creek. Young girls often helped out with younger siblings and relatives, giving them early training for a future in motherhood. (Below, courtesy of Robert G. Walton.)

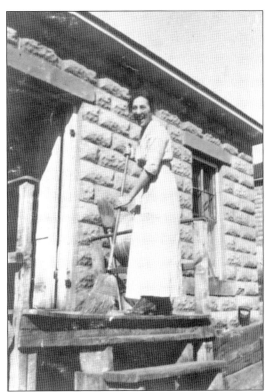

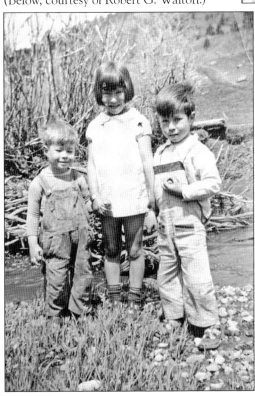

CLOTHING

Club member's Final Report Summary
State of New Mexico

Name *Elizabeth Cunja* Age *11* State *New Mexico*

P. O. *Sugarite* Community *Sugarite*

Year in this project (1st, 2nd, etc.) *2nd* County *Colfax*

Year in club work (1st, 2nd, etc.) *2nd* No. mos. in this year's project *5*

1. List the required articles you made *apron + sewing bag*

2. Number of required articles made for self *1* For others *none*

3. Total cost of materials for required articles *54 ¢*

4. Number of hours used in making required articles *8 hrs*

5. List articles other than the required ones made *dish towel*

6. List the home work you did No. of hours

7. Where did you exhibit your required articles? *no where*

8. Were you a member of a demonstration team in your county? *no*

9. Did you take part in the county demonstration contest? *no*

10. How many times did you give a demonstration in public? *not one*

11. What club office did you hold in the club this year? *none*

Signed:

Elizabeth Cunja
Member

The above report is true to the best of my knowledge:

Parent

CC-49 _____
Local Leader

Pauline Yaksich was six months pregnant with her youngest son, George Yaksich, third from left, when her miner husband died in an accident at Sugarite's sister camp Van Houten. Her other four sons in this 1951 portrait are, from left to right, Danny, Paul, Nickie, and Roddy. Sympathetic company officials helped her find work as a school janitor at Koehler Coal Camp, and she raised her sons on that salary.

Sewing was an important skill for women at the time, and they started early. Here, 11-year-old Elizabeth Cunja describes her 4-H Club projects in 1930. Elizabeth, also known as Liz, notes she spent eight hours and used 54¢ worth of materials to make an apron and a sewing bag as a required project. Sewing allowed working-class women to create and mend low-cost clothing for relatives.

This outdoor brick oven was built by Sugarite miner Angelo Recchia for his wife so she could bake bread to sell. She would build a wood fire inside the oven, heating the bricks. Then she would remove the wood and ash and insert the loaves to bake. She sold the bread for 15¢ a loaf and may have used the smell of baking bread to promote sales to bachelor miners. (Photograph by Patricia Walsh.)

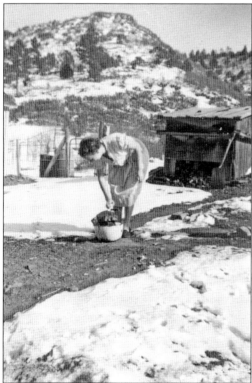

Coal camp women did any chores necessary to keep their families fed and warm. Here, Joyce McCormick Rossetti—who lived in Sugarite as well as Brilliant Coal Camp—gathers a tub of coal. Camp families burned coal in stoves to cook food and heat their houses. Boys gathered free scraps of coal fallen from coal cars en route to the tipple. Camp houses often had a coal shed out back. (Courtesy of Dorothy Kay.)

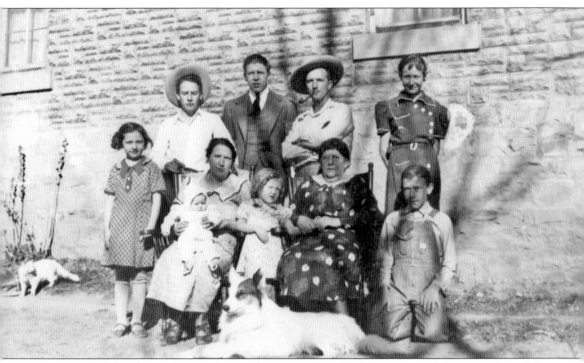

McCormick family members and pets gather in Sugarite Coal Camp around the 1930s. From left to right are (first row) Joyce, Gertrude holding baby Janet, Mabel, Kate Bartholomew (mother of Gertrude), and Lawrence; (second row) John, Bill, Charlie Bartholomew (brother of Gertrude), and Nellie. The family dog takes pride of place in this portrait, while a cat manages to make its way into the photograph on the far left. The Sugarite School appears to be the backdrop for the large family. Having an extended family provided lots of helping hands for babysitting and chores as well as boosting family earnings. The Bartholomew family, which included nine children, emigrated from England to Sugarite. Sugarite miners represented at least 19 nationalities and spoke at least seven different languages. (Courtesy of Dorothy Kay.)

Seven

Fun and Games

Usually their parents could not afford to buy them toys, but resourceful Sugarite Coal Camp kids easily conjured up fun. A makeshift rock dam across Chicorica Creek created a convenient swimming hole. A stick, some string, and a hook made a simple but workable fishing pole. Dried sunflower stalks, newspaper, and rags turned into high-flying kites.

Playing store with empty food cans and boxes, walking on stilts, "stealing" green apples from a nearby orchard, hiking, and having picnics were all warm-weather activities. In early winter, youngsters cut down trees to clear a sledding path on a hillside. Thick ice on Lake Alice and Lake Maloya provided hours of ice-skating fun.

For miners weary from grueling work, sports such as soccer and baseball provided a welcome break. Soccer most likely was introduced by mine bosses, who mainly hailed from Scotland, England, and Wales. Baseball teams competed against other camps or nearby towns. The St. Louis, Rocky Mountain & Pacific Company encouraged these morale-boosting events and may have purchased team uniforms.

Sugarite's immigrant miners varied in language, culture, and religion, and naturally drifted toward those of the same ethnicity. Knowing this, the company sought to provide a place where diverse camp residents could come together for recreation while assimilating into American life. The company also recognized that keeping the miners happy might prevent labor conflicts in the future.

As such, in 1918, the company built the Sugarite clubhouse, which quickly became the camp's social hub. The clubhouse boasted a billiard room, ice cream parlor, soda fountain, and sewing room. Dances, concerts, social affairs, and club meetings, as well as the occasional movie showing, took place in the ballroom.

Meanwhile, since Sugarite Coal Camp did not have a church, the clubhouse also served as a venue for Sunday religious services, led by priests and ministers from nearby Raton. At times, camp residents gathered around the Salvation Army van for lively prayer meetings, complete with drums and hymns, or as one resident said, "beat the drum and make the devil run."

In the spring of 1941, after the closure of Sugarite Camp, torrential rains sent roaring flood waters down Chicorica Creek. The flood severely damaged several camp structures, including the clubhouse. Mike Christos, the last clubhouse manager, later tore down the remains of that building.

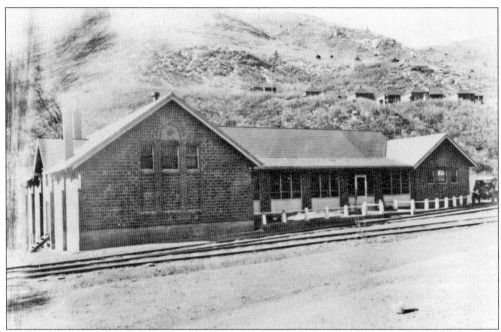

The clubhouse at Sugarite, seen here, played a central role in the camp's social life. The company showed movies in the building, and one old photograph caption noted that "Only high class moving pictures shown." Live bands and dances were also a regular feature. Since the camp did not have any churches, religious services also took place at the clubhouse. Note the vintage automobile at far right. Below, the clubhouse interior included a spacious central area with a soda fountain. There was one wing for women's activities (that is, sewing) and one for men's (billiards). Other than the Prohibition years, the clubhouse also served beer. (Both, courtesy of the Raton Museum Collection.)

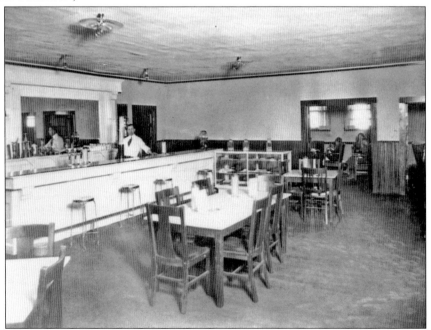

These Sugarite Coal Camp kids show off a fun mode of transportation around 1914 at the post office. Greg Stone (far left) rests his arm on the flank of an animal while chatting with brothers Donald (seated at rear) and William Evans. Donald and William were the sons of postmistress Mary Evans. An unidentified friend smiles while maintaining a steady hand on the reins of another animal.

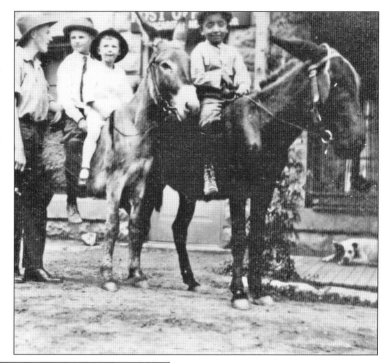

Bundled up against the elements, little William Evans poses in 1914 at the door of the Sugarite Coal Camp post office, where his mother, Mary, was the postmistress. The chubby-cheeked toddler clutches a spoon in one gloved hand and a small pail in the other. Some references say camp residents could buy ice cream at the post office.

These children at a coal camp enlist their four-legged friends to serve as carriage horses on a sunny day. The toy carriage is sophisticated, indicating it was likely store-bought. Wood houses in the background indicate this photograph was taken at a camp other than Sugarite, where the houses were made with block.

Brothers Bobby (left) and Jerry Owensby perch on a horse in front of a house at Sugarite Coal Camp. Both boys wear overalls, popular among camp boys and men. All the camp homes had front porches and fenced yards, as shown here. Many decades later, the Owensby brothers would return together to visit the abandoned coal camp after it had become part of Sugarite Canyon State Park.

The McCormick family lived near Sugarite's school, seen to the right. Nellie McCormick and her brother Bill pose with the dog Bill found wandering in the camp and adopted. Directly behind the McCormick house is a small building that could have been the shed where the family stored coal for fuel and home heating. Often camp children gathered the coal for free off mine waste piles. (Courtesy of Dorothy Kay.)

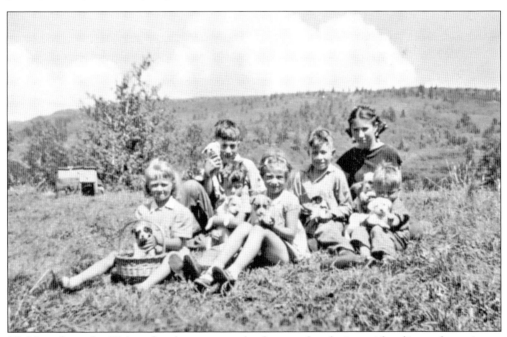

Children from the Walton family enjoy simple pleasures by playing with a litter of puppies on a hillside near the Roscheun House in Sugarite Canyon. From left to right are Shirley Walton Berry, Robert G. Walton, Jack Walton, Madlyn Walton Novick, Gary Walton, Wanda Walton Kamm, and Morgan Walton. (Courtesy of Robert G. Walton.)

Former Sugarite resident Mickey Baker recalls that when winter began, young people cut down trees to open a sledding path for fun throughout the season. One Christmas, Baker and his brothers Ben and Buddy received a much-desired sled, which they had to share. A few sleds are visible here, but many camp families were likely too poor to give them to their children. (Courtesy of Paula Grantham.)

When Sugarite Coal Camp closed in 1941, the McCormick family moved on to the camp at New Brilliant (formerly Swastika). Here, blowing bubbles is a fun activity for (from left to right) Dorothy McPeek, David McPeek, and their aunt Janet McCormick in the McCormicks' backyard. According to Dorothy McPeek Kay, a neighboring bachelor grew grapes and raised pigeons to sell. (Courtesy of Dorothy Kay.)

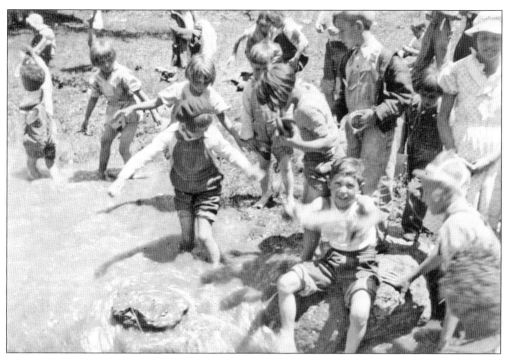

For the kids of Sugarite Coal Camp, having fun could be as simple as damming up a portion of Chicorica Creek, rolling up their pants legs, and wading in. For those residents preferring to stay dry, suspension bridges spanned the creek. At right, three Sugarite girls tote umbrellas, sport patches on their clothes, and wear tin cups on string around their necks. From left to right are Anna Borga, Betty Klantchnek, and Lina Giampietri. Perhaps they were taking part in a school play or pretending to be hobos. (Above, courtesy of Paula Grantham; right, courtesy of Katy Marchiondo.)

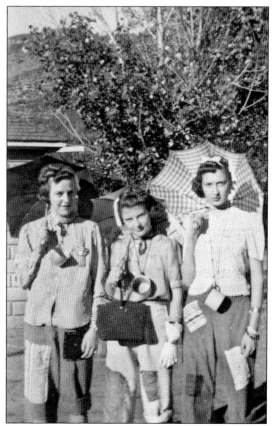

"Everybody loved everybody; we were just one big happy family," said former camp resident Lina Giampietri Cash. Often the bond of friendship forged in Sugarite lasted a lifetime. In the years following the closing of the camp, friends like these girls, pictured in Raton around the 1940s, continued to socialize. From left to right are (first row) Clara Popejoy, Betty Klantchnek, and Lina Giampietri; (second row) Emma Cunja and Marie Giampietri. (Courtesy of Pam Hunnicutt.)

New York financier Henry Ensign built this structure, dubbed the "White House," in the early 1900s. Future owner Claudio Vit and his family opened it to Sugarite youngsters for roller skating. Lina Giampietri Cash recalled that she and her friends would pack lunches, hike a half mile to the house, rent skates for 25¢, and stay all day. Decades later, remains of the hilltop house intrigued passersby. (Courtesy of Paula Grantham.)

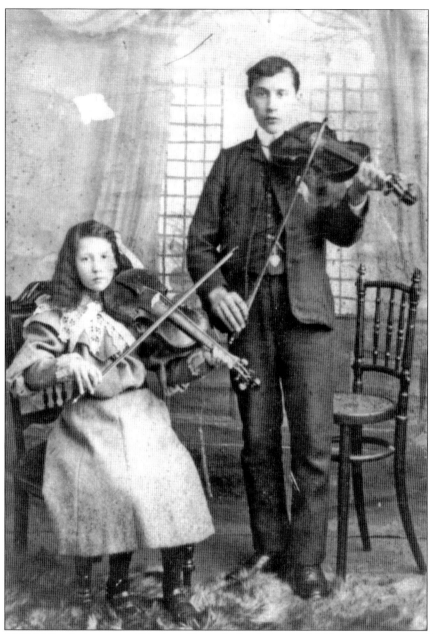

Richard "Dick" Bartholomew and his sister Gertrude Bartholomew McCormick entertained family and friends with their violin skills. The Bartholomew family emigrated from England, where the siblings were trained. Gertrude's granddaughter, Dorothy Kay, recalls that Gertrude played her violin only for the family, but her uncle Dick often played for the popular weekly dances at the Sugarite Coal Camp clubhouse. This formal portrait by a professional photographer indicates that the family placed considerable value on musical ability. At a time before recorded music was widely available, most entertainment at the coal camp was provided by live musicians and bands. Other schoolchildren of Sugarite Coal Camp got a chance to learn by being members of the Violin Club, which apparently was organized by one of the Sugarite teachers. Members of the club even had matching outfits. (Courtesy of Dorothy Kay.)

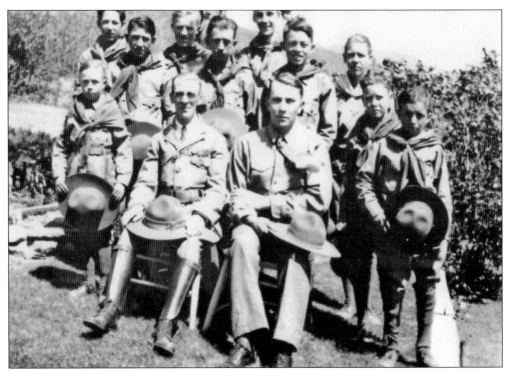

Sugarite Coal Camp boasted its own Boy Scout troop. Pictured here are many of the Scouts along with their leaders. The photograph was donated to New Mexico State Parks by Ronald Skinner, and the man with high boots and sunglasses is his father, the Scout leader.

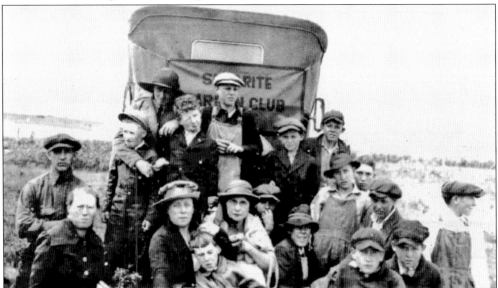

Not to be outdone by more urban societies, Sugarite Coal Camp residents organized their own garden club. Gardening is no easy feat in the dry and rocky pinyon pine–juniper ecosystem of lower Sugarite Canyon. Still, poor but self-reliant mining families grew vegetables, fruit trees, and flowers. The company eased the chore by piping water from the canyon's lakes into the coal camp. Every two houses had access to a water spigot.

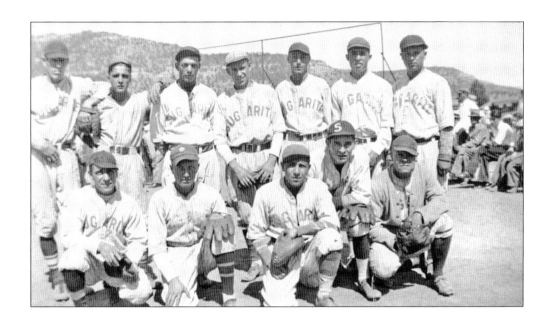

Sugarite Coal Camp loved its baseball team. The company sponsored baseball to entertain camp residents as well as to keep seasonally laid-off miners busy in summertime. The coal company was known to recruit workers who were good at baseball. From left to right are (first row) Lawrence Rodriguez, Bill Neish, Maben Rodriguez, Rich Gurule, and unidentified; (second row) Ben Baker, unidentified, Rico Angelo, Tony Srok, Fred Angelo, Alfred Fanelli, and unidentified. Below, Sugarite's baseball field can be seen edged by early-model cars. Johnson Mesa is in the distance. Baseball games were major social events at Sugarite, and most camp residents attended. (Above, courtesy of Pam Hunnicutt.)

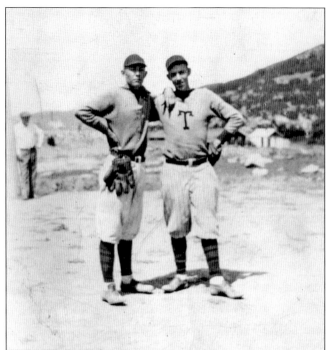

Buddies Lawrence Rodriquez (left) and Tony Srok, attired in their baseball uniforms, casually pose while anticipating a win for Sugarite one fine summer day. With a 1930s-era fielder's mitt hanging from his belt, Rodriquez is ready to play. Srok's uniform displays a large *T* representing the first initial of his name. Baseball games between coal camps were very competitive and highly attended. (Courtesy of Pam Hunnicutt.)

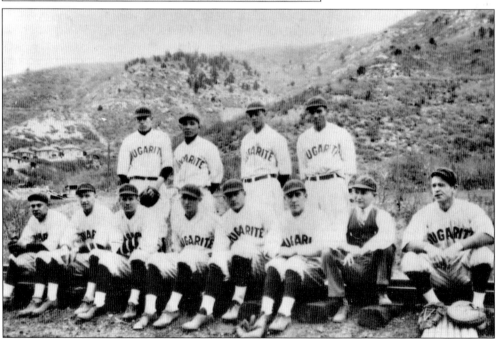

The names of Sugarite Coal Camp's baseball players reflect the numerous ethnicities of coal miners. At least one may have hailed from Japan, while others may have come from Italy and Mexico. From left to right are (first row) John Williams, Edward Shaber, Jess Short, Everett Gurule, Lawerance Rodriguez, "Dr." Currey (manager), and Joe Williams; (second row) Ben Baker, John Yoke, Rico Angelo, and Sam Sadoval. An early article about Sugarite suggested that company towns like it were eager to "Americanize" immigrant miners and their families.

Many immigrant miners at Sugarite played soccer in their home countries. Above, from left to right, Sugarite teammates Walter Hamilton, Dick Bartholomew, Dick Richards, Myrlin Davies, and unidentified are joined by mine superintendent Sandy Stuart. A newspaper account from the time said competing teams shared "tea" after a match, but many years later, former camp resident Joe Bertola insisted, "They weren't drinking tea, they were drinking whiskey!" "Tea" may have been a code word during Prohibition, when alcohol was illegal in the United States. The faces of the soccer players below reflect some of the 19 ethnicities in the camp. Sugarite mine workers hailed from many places, including Scotland, England, Mexico, and Eastern Europe.

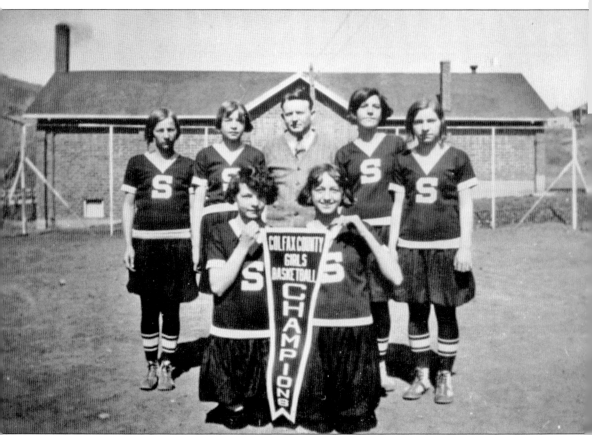

Members of the Sugarite girls' basketball team display their pennant as Colfax County champions. Members of the 1929–1930 team are, from left to right, (kneeling) Sarah Ross and Mary Pahor; (standing) Bessie Povlitch, Annie Pahor, coach Mr. Servis, Anna Panian, and Mary Tibljas. Sugarite School principal Loren Malcom insisted that all students participate in sports. Former camp resident Mary Cunja King said Malcom made her play basketball, even though she "wasn't good at sports." King said her team played the "husky farm girls" from a camp in nearby Yankee Canyon, who "played with their high-top work shoes, denim pants and cotton shirts. They threw that basketball from one end of the court to the other and we'd say 'Yankee Pass,' like they say 'Hail Mary' in football." The Sugarite boys' basketball team also won at least one championship pennant. (Courtesy of Richard Newton.)

Eight

TRIUMPH, TRAGEDY, AND TRUE LOVE

Many of the immigrant families living in Sugarite Coal Camp had left behind all things familiar to come to a new country with a different language and customs. They placed everything on the line in hopes of creating a new life for themselves and their families.

Apparently, in most cases, they succeeded. Children of poor parents born in Slovenia were welcome at the camp school, where they might excel in English penmanship by writing out a passage from the US Constitution in longhand. And while the children moved forward, their parents came to the school at night for classes with the goal of becoming US citizens.

Poor families lived and worked together in harmony. Home doors were left unlocked. There was nothing to steal. It is no wonder so many of the camp's children grew into adults with fond memories of Sugarite.

Still, humans are imperfect creatures, and occasionally the camp witnessed human tragedy. A 1930s clubhouse manager upset about issues in his marriage allegedly shot his wife and then himself, leaving his 12-year-old daughter an orphan.

But the camp also fostered cases of true love that blossomed into long marriages. The basketball-playing daughter of the stable boss eloped with a soccer-playing Sugarite youth. Family photographs testify to that long-lived love match.

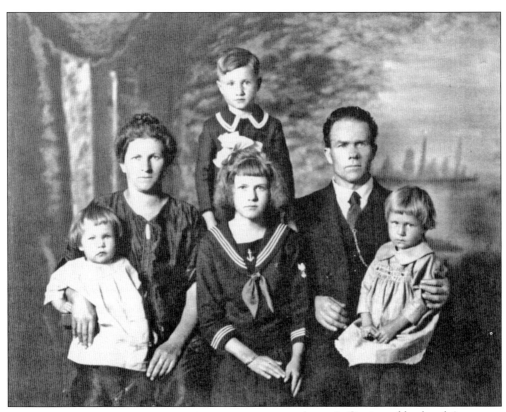

Elizabeth Cunja, Age 13, Eighth Grade
Sugarite, New Mexico
Mrs. Loren Malcom

PASSED BY
THE NATIONAL BOARD OF EXAMINERS

A B C D E F G H I J K L M N O
P Q R S T U V W X Y Z

a b c d e f g h i j k l m n
o p q r s t u v w x y z

1 2 3 4 5 6 7 8 9 0

Preamble

We, the people of the United
States, in order to form a more
perfect union, establish justice,
insure domestic tranquillity,
provide for the common defence,
promote the general welfare, and
secure the blessings of liberty to
ourselves and our posterity, do
ordain and establish this
Constitution for the United
States of America.

Antonia Cunja and husband Anton gather with son Mario, standing, and daughters (from left to right) Mary, Marcella, and Velma. Not shown are daughters Elizabeth, born in 1925, and Emma, born in 1928. The Cunjas epitomized many in Sugarite. They were ethnic Slovenians who immigrated to the United States in 1921. At Sugarite, miner Anton was buried in coal and suffered a broken back, leading to a nine-month hospital stay. But the Cunja children would become productive American citizens. At left is an example of 13-year-old Elizabeth Cunja's beautiful proficiency in penmanship, including the Preamble of the US Constitution. Sugarite officials once asked the Cunja family to take down a picture of Democrat Franklin D. Roosevelt and pressured the adults to vote Republican. The Cunjas laughed off their efforts and voted for FDR anyway. (Both, courtesy of Mary Cunja King.)

The National Board of Examiners

THIS CERTIFIES THAT

Elizabeth Cunja

has taken the Annual Penmanship Test of the National Board of Examiners, and the

Junior High School Penmanship Certificate

is awarded for having earned the passing score required for students of the _8th_ grade.

Given this _20th_ day of _April_ , 193*9*

BY THE CHIEF EXAMINER:

Mrs Loren Malcom
TEACHER

The National Board of Examiners
ACCEPTED

D. C. Spencer

Eighth grader Elizabeth Cunja received this certificate from the National Board of Examiners on April 20, 1939, for passing the Junior High School Annual Penmanship Test. Loren Malcom, often described as a beloved Sugarite teacher and school principal, served as one of the signers of the document. Immigrant miners did hard, grueling labor at Sugarite, but the coal camp provided their families a chance for US citizenship, as well as public education for their children. At right, Elizabeth Cunja, also known as Liz, poses for her eighth-grade photograph. (Above, courtesy of Mary Cunja King; right, courtesy of Paula Grantham.)

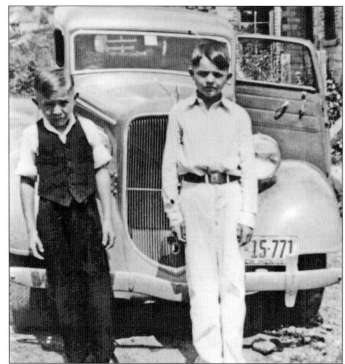

In 1936, Bobby (left) and Jerry Owensby pose by their dad's 1934 Plymouth. Their mom, Anna Owensby, served as postmistress of Sugarite Coal Camp, and their dad, J.G. Owensby, managed the company store. This photograph appears to have been taken near the camp post office. Below, in July 1994, Bobby (left) and Jerry Owensby revisit their boyhood home in Sugarite, where they lived from 1931 to 1937. They are standing outside the former post office near a sign that features the 1936 photograph of them as boys. The post office building now serves as the visitor center at Sugarite Canyon State Park.

Former camp residents remembered a small stone building behind the company store commonly known as the jail. Sugarite sheriff Alex Wersonick is shown with his wife, Janet. Their daughter Davida Wersonick White was born in Sugarite and lived there until age seven. She did not remember anyone ever being held in the jail. Some people may have gotten rowdy at Saturday night dances, but Sugarite generally was crime free. (Courtesy of Mozelle White Falletti.)

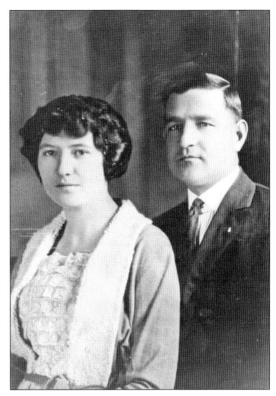

Davida Wersonick White displays fashion sense even as a toddler. Her father, Sugarite sheriff Alex Wersonick, regularly collected the company store's cash for deposit at a Raton bank. Once he gave little Davida the deposit bag to carry home. She was swinging it back and forth as she crossed the Chicorica Creek bridge, and the bag fell into the water. She does not remember what happened next, except that her father was furious. (Courtesy of Mozelle White Falletti.)

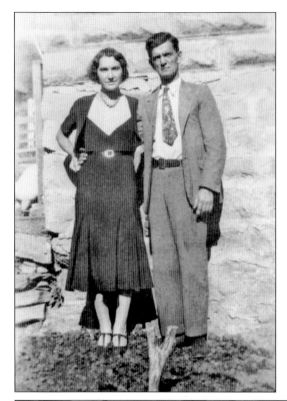

Tragedy looms for this couple. Sugarite clubhouse proprietor Andy Marcella wraps an arm around his wife, Karmella, sometime before the reported murder-suicide in which he allegedly took both their lives in June 1934. The couple had been estranged periodically for months. Karmella, 28, apparently helped her husband at the clubhouse, where miners came to socialize. She was visiting a nearby Oklahoma town to care for her ailing mother when her husband traveled there from Sugarite and allegedly shot her on a darkened street. Marcella, who was about 40, returned home and in murky circumstances was reported to have shot himself twice in the heart. Below, simple markers identify their graves in the Mount Calvary Catholic Cemetery in Raton. The Marcellas were survived by their 12-year-old daughter, Alice. (Left, courtesy of Mary Cunja King; below, photograph by Patricia Veltri.)

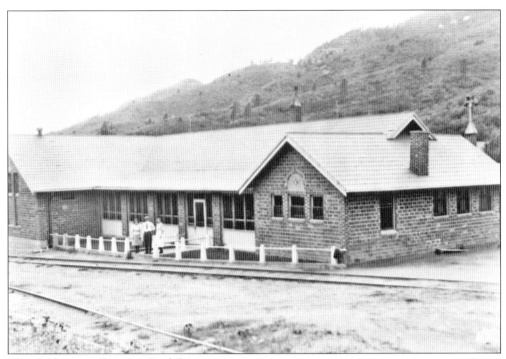

The clubhouse at Sugarite Coal Camp was a hub for social gatherings. The company hired bands for dances and showed movies. There was a soda fountain, and the clubhouse also sold beer when Prohibition was not in effect. The clubhouse had various proprietors, including Andy Marcella. (Courtesy of the Raton Museum Collection.)

Alice Marcella Botto shows a flair for style in her coat and hat with feathers attached. Alice was 12 when her father, the proprietor of the Sugarite Coal Camp clubhouse, allegedly shot her mother and then committed suicide. She was staying with her maternal grandfather at the time. (Courtesy of Mary Cunja King.)

Sugarite stable boss John Joe Ross, shown here as a young man, was born on January 10, 1887, in Braidwood, Illinois. Stable boss, or muleskinner, was an important position at the coal camp, since the mules were essential in the production of coal. The miners were said to have grumbled that the company valued the mules more than the men. The animals were let out of their stalls in the morning and were trained to go up the hill on their own to the mine level. After a day's work, they ran back down for water and food. Below, resplendent in her turn-of-the-century finery, John's wife, Davida Lee Ross, must have turned many heads in her youth. (Both, courtesy of Richard Newton.)

Sarah Ross, daughter of stable boss John Ross and his wife, Davida, poses with her Sugarite beau and future husband, Richard Murray. Sarah played on the Sugarite girls' basketball team, the Colfax County champions in 1929–1930 (see page 96). Here her V-neck top, banded socks, and athletic shoes indicate she wrapped her winter coat over her basketball uniform. Richard "Dick" Murray was also an athlete, playing on Sugarite's champion soccer team for 1937–1938. Dick Murray started working in the Sugarite mines at age 12 as a bone picker, and a few years later became a miner for several years. Sarah and Dick eventually eloped, to the displeasure of Sarah's mother. Below, Dick and Sarah (right) display Western flair later in their married life while posing with their daughter JoAnn Murray. (Both, courtesy of Richard Newton.)

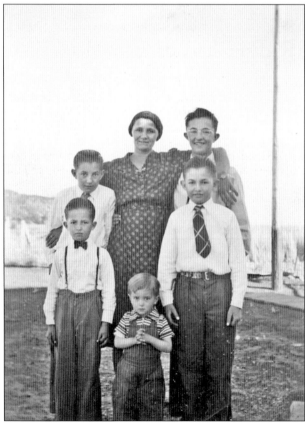

This portrait of George Yaksich, his wife, Pauline, and their four sons was taken before George died in a mining accident on his wife's birthday, July 14, 1937, at Van Houten Coal Camp. Their sons are, from left to right, Roddy, Paul, Nick, and Danny. Pauline Yaksich was six months pregnant with the couple's fifth son, George "Judo," at the time of her husband's death. Sympathizing with her plight as a widow with five boys, the St. Louis, Rocky Mountain & Pacific Company gave her a job as school janitor at Koehler Coal Camp. She raised her sons on that salary. At left, Pauline Yaksich poses with her five sons a few years later. (Both, courtesy of George "Judo" Yaksich.)

Nine

SISTER CAMPS AND SORROWFUL NEIGHBORS

The St. Louis, Rocky Mountain & Pacific Company owned six other mines in addition to Sugarite, all in isolated canyons in Colfax County.

Sugarite's sister camps were Blossburg (1881–1905), five miles northwest of Raton; Brilliant (1906–1935), seven miles northwest of Raton; Gardiner (1897–1940), three miles west of Raton; Koehler (1907–1957), 16 miles southwest of Raton; Swastika (1919–1954), six miles west of Raton (renamed Brilliant II or New Brilliant in 1940); and Van Houten (1902–1952), 18 miles southwest of Raton.

Camp towns, so called because many started with only tents, were constructed out of necessity to house miners with no means to commute from Raton or other nearby towns. The layout of all the SLRMP camp towns was basically the same. Each town provided easy access to the mine. Houses built in neat rows sheltered miners' families, while bachelors usually lived in a boardinghouse. A school, company store, doctor's office, and clubhouse served camp residents. Generally, SLRMP camps were peaceful, with little labor unrest and few fatal accidents.

That was not the case for other mining camps in the region. For example, about 40 miles to the northwest in southern Colorado, a strike by miners at the Rockefeller-owned Ludlow Mine led to tragedy. Company guards, assisted by the Colorado National Guard, attacked a makeshift tent camp of striking miners in 1914. Eleven children and two women died in what would become known as the Ludlow Massacre.

Meanwhile, Sugarite's big and fancy neighbor, Dawson, with a population of about 9,000 some 40 miles to the west, would see its share of sorrow. Two mine explosions 10 years apart, in 1913 and 1923, killed more than 380 men. A vast cemetery still testifies to the losses for families, who in some cases lost a father in the first blast and a son in the second.

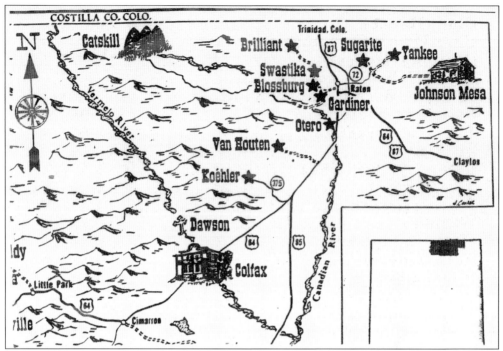

This illustration shows the location of the seven coal camps established by the St. Louis, Rocky Mountain & Pacific Company in northeastern New Mexico—Sugarite, Brilliant, Swastika, Blossburg, Gardiner, Van Houten, and Koehler. The camps of Yankee and Dawson were owned by other companies. Dawson, about 40 miles southwest of Sugarite, was a large camp that suffered two major mine explosions resulting in more than 380 deaths.

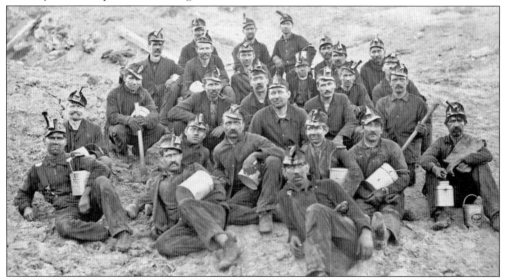

These dirty-faced miners rest at Brilliant, one of Sugarite's six sister camps. The oil headlamps indicate that this is an early photograph. Some men have picks and lunch buckets. The lunch buckets had an upper compartment for food and a lower one for water. At Sugarite, a former resident said one miner got tired of his coworkers stealing his water, so he dealt with the problem by storing his false teeth there.

Club Houses	$ 86,664.12
Club House Furniture & Fixtures	10,668.57
Dwelling Houses	73,324.48
Extraordinary Repairs	37,681.19
Electric Wiring and Equipment	34,238.96
Rails and Fastenings	24,956.90
Tipple at Swastika	22,057.02
Pit Cars	18,867.93
Company Buildings	14,629.17
Water Plants	14,001.22
Railroad Yard at Swastika	12,818.61
Washery	10,792.21
Mine Equipment	9,966.57
Bath Houses	9,574.80
Ventilation	7,484.59
Aerial Tramway	5,897.04
Tipple Equipment	5,450.27
Prospecting	5,281.55
Outside Haulage	5,110.06
Mules and Horses	5,070.00
Machine Shop Equipment	5,047.66
Wagon Road Bridges	3,306.92
General Office Furniture & Fixtures	2,007.91
Tracks	1,858.10
Mine Rescue Apparatus	1,758.87
Extending Tipple at Swastika	1,184.79
Civic Centers	1,130.71
General Office Typewriters	838.38
Mine Office Furniture & Fixtures	834.63
Mine Entries	524.29
Hospital Furniture & Fixtures	476.52
Fire Protection Equipment	221.04
Miscellaneous	143.34
Total	$433,868.42

This list shows expenditures for improvements at the seven coal camps run by the St. Louis, Rocky Mountain & Pacific Company. Published in the company's 1919 annual report, the list shows that the SLRMP spent $433,868.42 from its profits at the camps in northeastern New Mexico, including Sugarite. Expenses for all the clubhouses make up the top two items, together more than $96,000. Housing for the miners comes in next at more than $73,000. The company spent $5,070 on mules and horses. Note that expenses for the hospital at Gardiner, which was used by all the camps, is near the bottom of the list at $476.52. (Courtesy of the Arthur Johnson Memorial Library.)

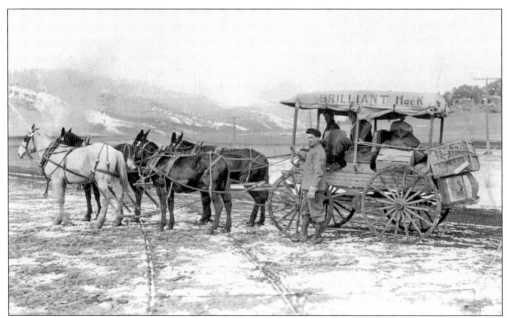

Brilliant was one of six sister coal camps to Sugarite. All seven were run by the St. Louis, Rocky Mountain & Pacific Company. Here, mules haul a sort of stagecoach transporting passengers, freight, and mail over snow-covered ground. Note the box on the back with the lettering "Return to Raton Bakery."

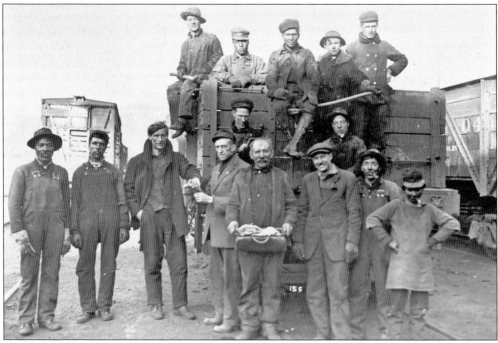

Miners at Gardiner Coal Camp, west of Sugarite, visit with a company doctor. It appears the doctor may be the third man from the left, possibly holding a miner's injured hand. The man holding the doctor's medical bag appears to be one of the miners. Gardiner was the site of the hospital for miners working in Sugarite and its sister camps.

Baseball, vintage cars, and horses in their corral combine for a unique image of the ball field at Gardiner Coal Camp. The St. Louis, Rocky Mountain & Pacific Company sponsored baseball teams in each of its seven coal camps, including Sugarite. Baseball games between the camps were popular entertainment in the summer. (Courtesy of the Raton Museum Collection.)

A youngster perches on a mule pulling a water wagon in Sugarite's sister coal camp of Van Houten. Sugarite residents were lucky in that the company piped in lake water from up canyon, and every two houses shared an outdoor water spigot. They used the water for bathing, laundry, and household chores, while boys fetched spring water for drinking. At other nearby coal camps, residents had to purchase water from vendors.

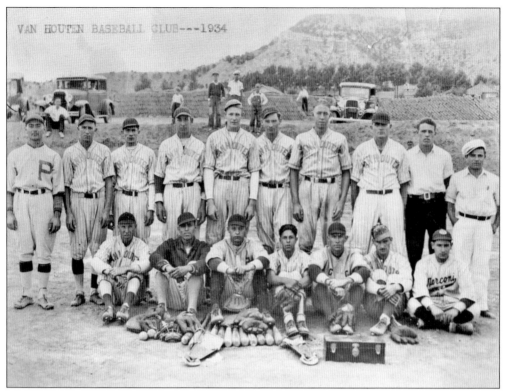

With curious onlookers watching from the background, members of the Van Houten baseball team gather for this 1934 photograph. The people and cars behind the team suggest the picture may have been taken before a game. Baseball games between coal camps such as Van Houten and Sugarite, a few miles away, were highly competitive and well attended by camp residents.

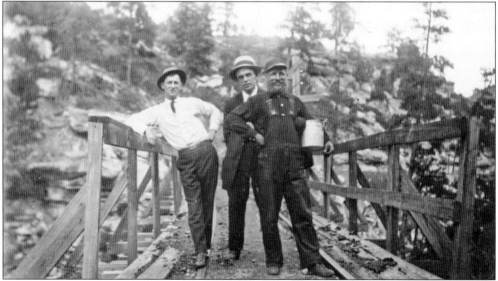

A happy miner sporting huge mutton chop sideburns stands proudly on a rail bridge with two men in "city clothes" in this image from Koehler Coal Camp. The camp was named for one of the founders of the St. Louis, Rocky Mountain & Pacific Company.

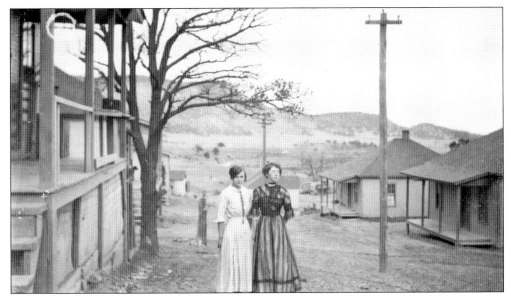

These women in turn-of-the-century dress stand in the street in Koehler. Note the wood-frame houses and the poles carrying either electric or telephone lines through the town.

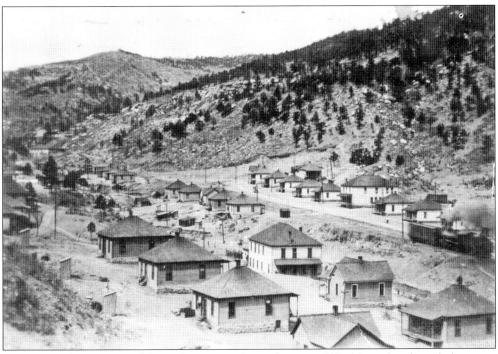

Neat rows of square, wood-frame houses in the coal camp of Koehler echo the tidy layout at Sugarite Coal Camp. As in Sugarite, the homes include front porches, outhouses, and foundations apparently made of sandstone. However, the homes in Sugarite were made from block. Note the smoke billowing from the locomotive at right.

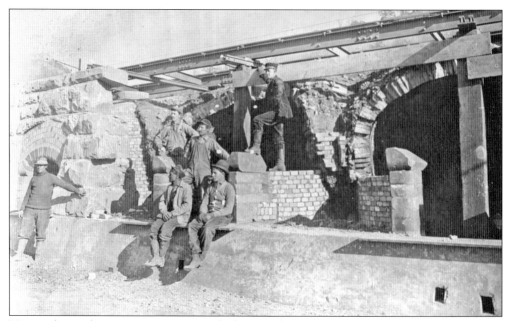

Men work on coke oven construction in the large coal mining town of Dawson, run by the Phelps Dodge Corporation. Coking transforms coal so that it can be used for industrial purposes, such as making steel. At Sugarite Coal Camp, about 40 miles northeast of Dawson, the bituminous coal could not be coked and was used instead for home heating and to run locomotives. (Courtesy of the Raton Museum Collection.)

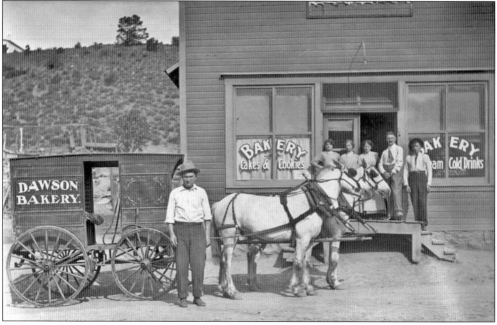

Cakes, cookies, and cold drinks were available at the Dawson Bakery, which even boasted its own delivery wagon. Dawson Coal Camp had about 9,000 residents, compared to a maximum of 1,000 at Sugarite Coal Camp. While there was no bakery at Sugarite, the clubhouse there offered ice cream and candy.

The phrase "company store" does not begin to describe the majestic mercantile at Dawson, the largest coal mining community in the region that included Sugarite Coal Camp. This impressive, three-story structure with plate-glass windows and architectural flair would have been at home in any large city. Sugarite's company store was tiny in comparison but stocked essentials such as flour, canned goods, meat, and work tools. Below, the elegant store interior served stylish women and their children.

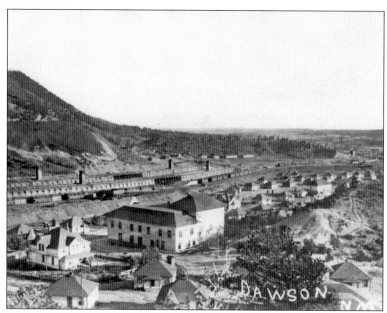

The opera house and long lines of coke ovens dominate this view of Dawson. While Dawson offered more amenities, Sugarite had the better safety record. During its 30-year lifespan, about five people died in mine accidents at Sugarite. Dawson, however, suffered two major mine explosions 10 years apart that killed more than 380 people.

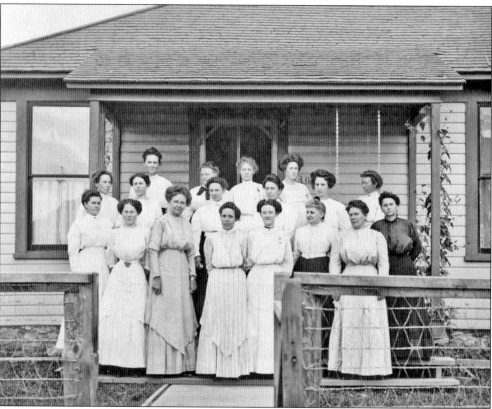

Members of the Order of the Eastern Star gather in Dawson in 1913. The woman dressed in dark clothing on the right may have been a widow wearing black during a mourning period. The Order of the Eastern Star was created for female relatives of male Freemasons. Freemasonry is a philanthropic fraternity and social organization.

This gritty industrial scene reflects the vast scale of mining operations at Dawson Coal Camp. Dawson, founded in 1901, had 10 mines compared to Sugarite's three. The Phelps Dodge Corporation purchased Dawson in 1906. Dawson operated as the largest coal mining operation in New Mexico until it closed in 1950, nine years after Sugarite.

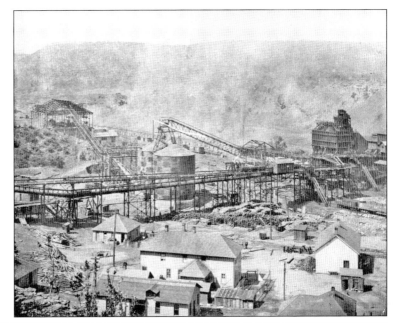

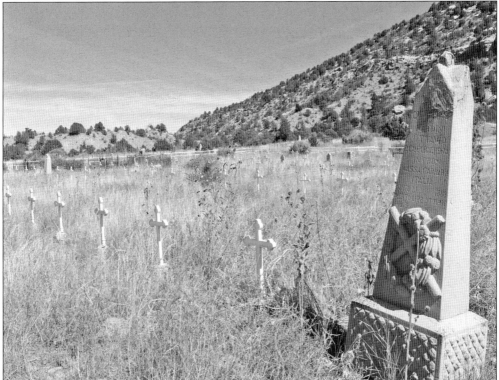

More than 380 Dawson miners died in two explosions in 1913 and 1923. Some who died in 1923 were sons of 1913 victims. The first explosion was caused by a dynamite charge, the second from sparks after a mine car derailed. Many of those killed were immigrants, such as the man honored by this tall gravestone engraved in Italian. Dawson's cemetery is listed in the National Register of Historic Places. (Courtesy of Jim Veltri.)

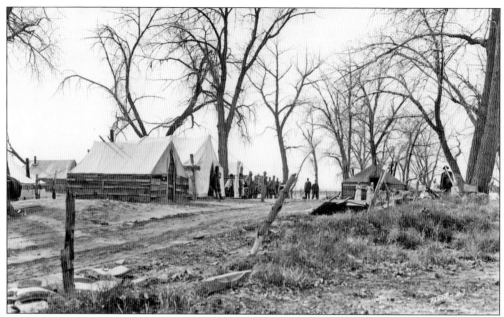

The Ludlow Massacre spurred unionization of miners early in the 20th century. Ludlow was a mining camp in southern Colorado, about 45 miles northwest of Sugarite Coal Camp. Striking Ludlow miners moved their families off company property and into a tent camp, part of which is shown above. The miners dug pits under the tents so their families could get below ground level when company guards fired pot shots. Amid ongoing conflict between miners and company guards, the Colorado National Guard was sent to keep the peace. However, National Guardsmen began siding with company guards. In April 1914, company guards and National Guardsmen attacked, setting fire to the tents. Eleven children and two women died in a pit under one of the tents. The burned camp and the infamous pit are seen below. (Both, courtesy of Pueblo County Historical Society, Pueblo, Colorado.)

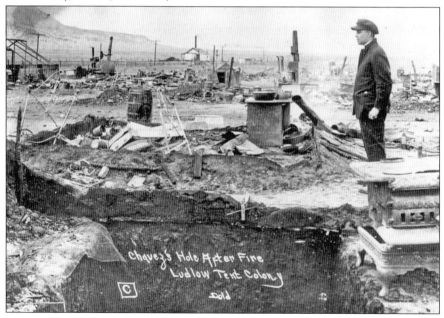

Ten

DEATH OF A CAMP, BIRTH OF A PARK

By the late 1930s, while still widely used, coal had been dethroned as the king of fuel. Petroleum products like propane and natural gas began replacing coal for heating homes. Railroads converted their coal-burning locomotive engines to diesel. Sugarite Coal Camp began shrinking.

In a poignant echo of history, Sugarite operated in its last year on a limited basis as a wagon mine, selling coal straight from the tipple. The *Raton Range* newspaper reported that in a departure from policy, the St. Louis, Rocky Mountain & Pacific Company was trying to keep the camp open "because of a certain demand for the Sugarite coal."

But in April 1941, a *Raton Range* headline proclaimed, "Rocky Mountain Announces Closing of Sugarite May 1." The closure affected 58 men, including some company officials.

Once the camp closed, equipment was sold or stored for future use. The company tore down most of the camp buildings and salvaged the materials. Company officials had offered the houses to the residents for $50, but very few could afford the price, which did not include moving fees or a lot to set it on.

Some miners found jobs in New Brilliant, one of the few remaining SLRMP camps still in operation. Sugarite School was discontinued in December 1941. Camp residents gradually moved out of Sugarite, but some stayed as long as two years before finding work elsewhere.

The City of Raton eventually obtained the site of the coal camp as well as most of the rest of Sugarite Canyon, which still serves as Raton's watershed. The canyon became a city park for some 40 years, but facing a lack of resources to maintain the area, the city decided to lease the land to New Mexico State Parks.

Sugarite Canyon State Park was born in 1985 and turned into a major camping and fishing destination. But the remains of Sugarite Coal Camp comprise a primary attraction as one of the only such camps open to the public. A trail winds through camp foundations, and signs tell the stories of Sugarite mining families, who were poor in money but rich in life.

From mid-April to early May 1941, the weather station in Raton reported more than five inches of rain. According to a *Raton Range* report on May 1, the torrential rainfall "washed out bridges and roads and sent the usually placid Sugarite [Chicorica Creek] raging down the canon [canyon] out of control." On May 2, the *Range* reported that a water line supplying drinking water to Sugarite had been ripped out by the floodwaters, and "hasty repairs were being made to restore services." The image above illustrates how floodwaters washed away part of the bank closest to the railroad tracks where cars received the coal from the Sugarite tipple. The remains of the clubhouse are believed to be pictured below. (Both, courtesy of Katy Marchiondo.)

A dog rests on empty steps at the Sugarite company store, possibly after the camp closed in 1941. During its heyday, the store possessed a refrigeration plant, presumably for storing meat. The mercantile sat beside the railroad tracks, which probably assisted in stocking the building with imported products like coffee, sugar, and flour, as well as hardware like picks and shovels, which miners had to buy themselves.

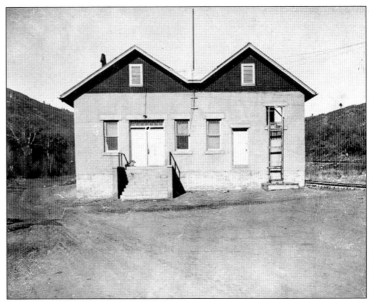

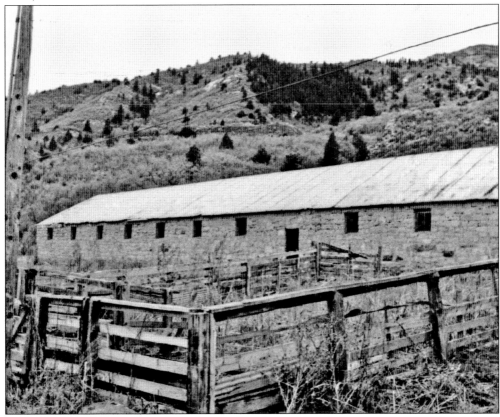

Abandoned and overgrown with weeds, corrals at Sugarite's mule barn stand empty after the coal camp closed. The 40-stall facility played a key role, housing the mules that pulled coal cars during daytime shifts in the mines. The barn was one of a few buildings left standing when the camp closed in 1941. Today it is used as part of the operation of Sugarite Canyon State Park.

WE NOW HAVE ALL THE

KOEHLER HOUSES

FOR SALE

3, 4 and 6-Room Wood-Frame Houses

All exceptionally well constructed. Suitable for homes, cabins and a few houses suitable for barns or sheds. Unbelievable low prices. 3 room houses $700 up. 4 room houses $900 up. These prices include moving within 25 miles, $1.00 per mile over 25. These houses may be moved into Raton. Can finance if you own your lot. These are better houses than offered before at Koehler or Dawson.

H. P. Vaughan or Marcos Baca

OFFICE: First house on left as you enter
Koehler — Open 7 days a week
PHONE: 036-J3 Koehler or
Phone 40 Extension 5, Raton, in evenings

From an era before big trucks, this image takes the idea of horsepower back to its origins. Here teams of horses haul a coal camp–style house to its new site. Although the location of this photograph is unknown, many houses from Sugarite's sister coal camps were purchased and relocated. The 1955 newspaper advertisement at left offers houses for sale from Koehler Coal Camp. Sugarite had already been closed for 14 years by the time of this notice, which offers three-room, wood-frame houses starting at $700 and four-room houses starting at $900. The town of Raton contains many square, wood-framed houses likely relocated from area coal camps. Probably very few whole structures were moved from Sugarite because of the coke-block construction. Instead, the company tore down most buildings there and salvaged the materials.

This sign greets visitors to Sugarite Canyon State Park. A trail winds through the remains of Sugarite Coal Camp, one of very few on public land. After the camp closed in 1941, the City of Raton obtained Sugarite Canyon, a major watershed for the town six miles away. Raton ran the area as a city park for about 40 years. Sugarite Canyon State Park was created in 1985. (Photograph by Patricia Walsh.)

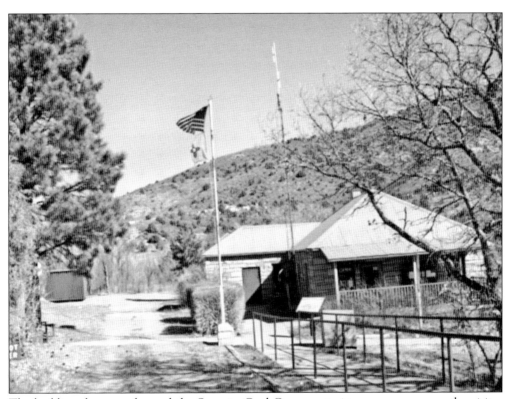

The building that once housed the Sugarite Coal Camp postmistress now serves as the visitor center for Sugarite Canyon State Park. A few camp building foundations can be seen low on the hillside and just above the driveway area. The lighter patch higher up and behind the flagpole is actually an outcrop of sandstone on the hillside. (Photograph by Patricia Walsh.)

Bob Dye served as the first park superintendent after the coal camp became part of Sugarite Canyon State Park in 1985. Dye, who retired in 2012, oversaw the creation of a trail system through the camp remains and the installation of signage on camp history. During living history events recreating camp life, he frequently appeared in overalls and a miner's helmet, with a pick slung over his shoulder and "coal dust" on his face. (Courtesy of Bob and Jan Dye.)

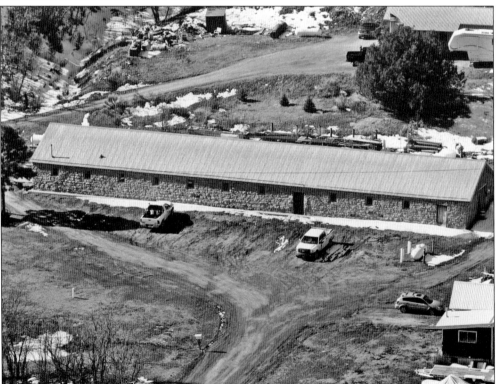

The mule barn from the time of Sugarite Coal Camp remains in use as part of the operation of Sugarite Canyon State Park. The barn originally had about 40 stalls for the mules that pulled coal cars in the mines. The stable boss was responsible for caring for the mules and their gear. Miners were known to complain that the mules received better care than the men. (Courtesy of Jim Veltri.)

A coal car once used at Sugarite Coal Camp stands in mute testimony to local mining history. One coal car could hold a ton of coal, and mules pulled the cars through the mine tunnels. On a good day, a miner could extract about five carloads of coal, earning about $5. During that era, Sugarite's miners extracted coal as a vital energy source for the growing nation. Those men could not know that future generations would learn that burning coal pumps extra carbon dioxide into the atmosphere, creating the equivalent of a heat-trapping blanket around the planet and changing the earth's climate. These days, Sugarite Canyon State Park uses solar panels for some energy needs. This old coal car stands near Sugarite's former post office. The building now serves as the park's visitor center, where thousands of visitors each year learn the story of Sugarite Coal Camp. (Courtesy of Jim Veltri.)

Rock walls and an iron door remain from Sugarite's dynamite shack. The structure protected miners from accidental explosions but also guarded the dynamite from any miners tempted to take some for unauthorized blasting. It is thought that some mine explosions at other camps were caused by miners desperate to reach more wage-producing coal. At Sugarite, each night, a special crew set off dynamite. The next day, miners picked through the rubble.

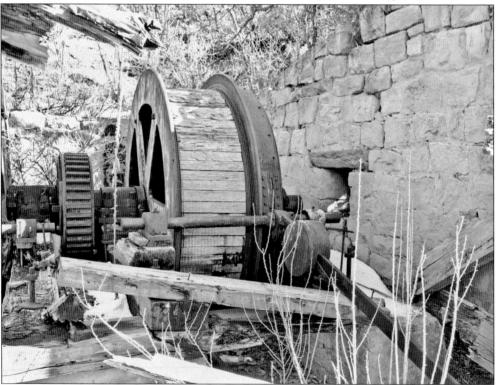

This close-up view of the Sugarite wheelhouse shows one of two large cable wheels used to raise and lower coal cars between the mine level and the tipple below. Cable wrapped in opposite directions around the wheels allowed loaded coal cars to be lowered down the hillside. The weight of those cars brought up empty cars in an ingenious pulley system that worked by gravity alone. (Courtesy of Jim Veltri.)

Mine 2 was the most productive of three mines in Sugarite Canyon, with about 11 miles of tunnels. Sugarite Coal Camp closed in 1941, and today, all three mine entrances have been sealed or have collapsed. This photograph shows the ironwork that was placed at the entrance of Mine 2 before the opening fell in. The rock walls leading up to the entrance are still visible.

Closer inspection of what appears to be a hillside dotted with Rocky Mountain juniper reveals remains of sandstone block foundations of Sugarite Coal Camp. The foundations still stand in the camp ruins, which are part of Sugarite Canyon State Park. When the camp closed, most buildings were torn down for salvage.(Courtesy of Jim Veltri.)

DISCOVER THOUSANDS OF LOCAL HISTORY BOOKS FEATURING MILLIONS OF VINTAGE IMAGES

Arcadia Publishing, the leading local history publisher in the United States, is committed to making history accessible and meaningful through publishing books that celebrate and preserve the heritage of America's people and places.

Find more books like this at
www.arcadiapublishing.com

Search for your hometown history, your old stomping grounds, and even your favorite sports team.